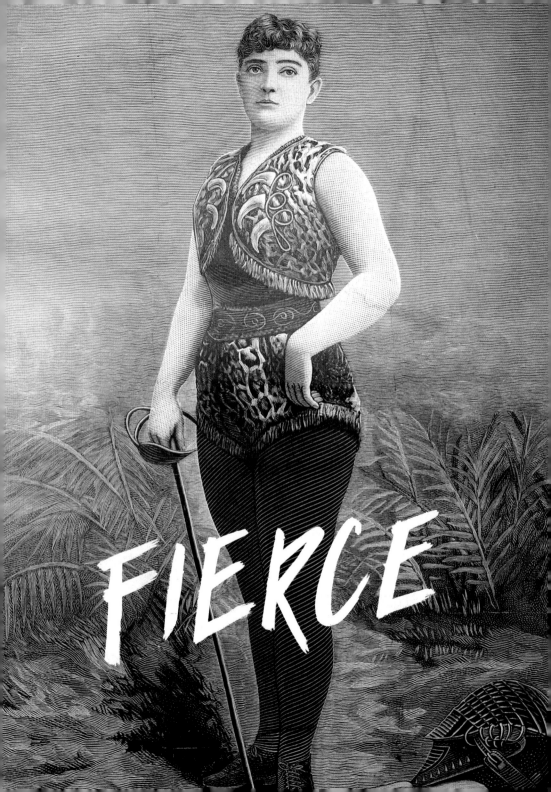

FIERCE

THE HISTORY OF LEOPARD PRINT

JO WELDON

HARPER DESIGN

An Imprint of HarperCollins Publishers

Page 1: Jaguarina, champion
sword fighter of the 1800s.
Big cat spots were often worn
by strongwomen and other
exhibition athletes. Female
athletes often gave themselves
dramatic and inventive stage
names, including ones inspired
by mythological figures such as
Minerva and Athena.

FIERCE
Copyright © 2018 by Jo Weldon

All rights reserved. No part of this book may be used or
reproduced in any manner whatsoever without written
permission except in the case of brief quotations embodied
in critical articles and reviews. For information address Harper
Design, 195 Broadway, New York, New York 10007.

HarperCollins books may be purchased for educational,
business, or sales promotional use. For information
please email the Special Markets Department at SPsales@
harpercollins.com.

Published in 2018 by
Harper Design
An Imprint of HarperCollinsPublishers
195 Broadway
New York, NY 10007
Tel: (212) 207-7000
Fax: (855) 746-6023
harperdesign@harpercollins.com
www.hc.com

Interior design, handlettering, and illustrations by Laura Palese

Cover pattern © Shutterstock/Leavector

Distributed throughout the world by
HarperCollins Publishers
195 Broadway
New York, NY 10007

ISBN: 978-0-06-269295-5
Library of Congress Control Number: 2017945067

Printed in China

First Printing, 2018

For the BIG CATS, the people they INSPIRE, and the people who work to preserve their lives and HABITATS.

CONTENTS

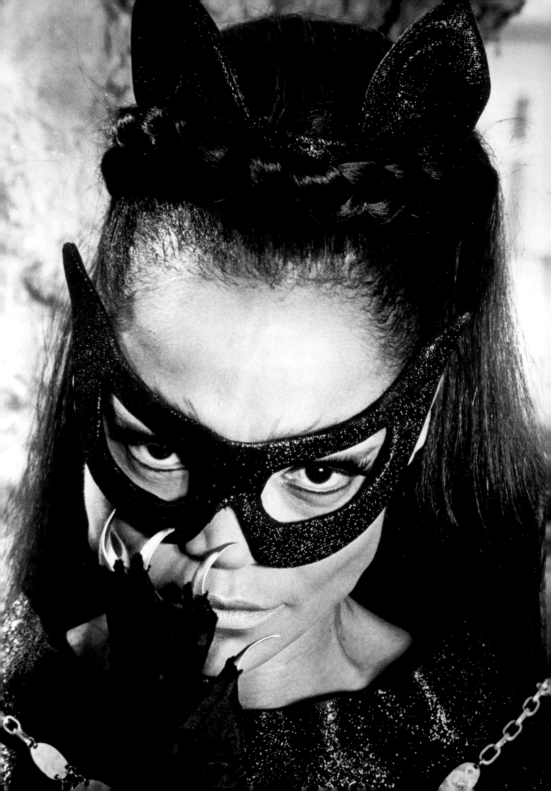

CATWOMAN COMES ALIVE

THOUGH SHE BE BUT LITTLE,
SHE IS FIERCE!

—William Shakespeare

W hen I was a young girl, I thought Catwoman was real. I also believed in Santa Claus, the Tooth Fairy, and the Easter Bunny, but here's the difference: I still believe in Catwoman. I've seen her in the flesh.

It was inevitable that I should be enamored of Catwoman, as I was born to feel kin to cats. I'm a Leo, born in August, in the Year of the Tiger, 1962. I've always taken both pleasure and pride in these associations. Being from Colorado, I was told to look out for pumas and lynx on family trips into the mountains (possibly as an alternative to taunting my sister). I sought them out avidly in the wild, but the first time I actually saw a big cat was in a preserve, where I spied a group of spotted cubs with their mother, a mountain lion, and thought, "They're like me! I'm a little lion!" Perhaps I would grow up to bear resemblance to the ocelots I also saw—small yet feral and powerful. While my interest in these dangerous and enthralling animals has never waned, indeed has increased over the years, it was Catwoman, of the terrifically campy 1960s *Batman* television show, who made me believe I could embody them.

Watching the show, I wasn't interested in Batman's attempts to preserve the status quo. Instead, I was entranced by a sleek, chic, tiny, and ferocious woman dressed in a skintight suit—her voice deliciously purring and taunting; her whole body engaged in her mischievous laugh; her

Previous spread: Eartha Kitt looks fierce in her Catwoman mask. "I loved playing Catwoman," she said in her autobiography, *Confessions of a Sex Kitten.*

dazzling eyes widening with a mad energy that delighted me: Catwoman. She spoke in terrible puns, my favorite language. She aspired to have the world's largest closet, which seemed a totally worthy life goal to me. Though she wore a black catsuit, she was framed by the leopard print that covered the walls and furniture of her lair, and I loved leopard print. She had killer style. And she was a natural-born leader, complete with henchmen in tiger-print suits. I wanted henchmen in tiger-print suits, too.

Batman repeatedly defeated her, but that meant nothing to me. I believed that no matter how many battles she lost, she'd eventually win the war. No mere man—Batman or anyone else—could truly vanquish a magnificent woman like Catwoman. Glamour was her superpower. Ambition was her strength. She dared to want everything her way, for herself, and on her own terms. She was the boss. Catwoman wanted to transform the world into her playground. Who wouldn't rather live in Catwoman's world, a place where everyone wore brightly colored, gorgeous clothing? Who didn't want to be outrageous? Who didn't find the villains more titillating than Batman, whose alter ego was all big business and law and order?

I confused Eartha Kitt with Catwoman's alter ego, in the way Bruce Wayne's was Batman. Over the years, of course, other actresses have portrayed Catwoman, but Kitt was the one I was invested in. I cherished a photograph of Kitt from an old magazine in which she wore a fantastic matching full-length leopard coat and dress made of fur or velvet, leading a cheetah by the leash. The image was glamorous, fantastic, and self-assured. She was not only everything I wanted to be, she was also everything I wanted everyone to be.

My father took me to see her perform in a nightclub when I was a child. I was much too young—perhaps six or seven years old—to have been allowed inside, but there I was. Kitt owned the stage and the audience, purring and snarling and laughing at us. She sang songs about having her way with people and about being clever and resourceful. She transcended everyday struggles, encouraging us to cast off the dubious rewards of respectability, and the woman's assigned role of being seen but not heard. She was motivated by neither punishment nor reward. She just *was*. She

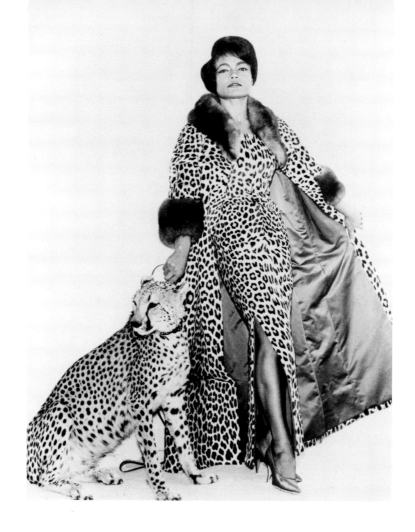

could live without my adoration, and that was precisely what I adored about her. I sensed that everyone in the cabaret felt daring just for watching her. She knew it and was amused by our reserve. Yet she loved entertaining us, mere mortals that we were. She indulged us and accepted our applause as her due.

After the show, she came over to our table, sparkling and lithe in a beaded gown, and said, "Hello, little girl. Your father said you wanted to meet me." I was starstruck, speechless. She threw back her head and laughed, gave me a little wave, and moved on. I felt chosen. Catwoman had talked to me.

All my secret goals in life suddenly evolved into a single desire: to be as fabulous as Catwoman. I didn't need things or attention. I simply wanted to exist in a state of fabulousity, a state, I believed, that could be as real for me as it was for her.

On May 4, 1970, a different kind of reality crashed in on me through the television set, when a group of military police fired on a crowd of students protesting the Vietnam War at Kent State University, killing four. The story and images were everywhere. The adults around me talked of nothing else.

This incident made me see that there was more to the world than my sheltered space, and the impact of it led me, when I got a bit older, to learn more about anti-war protests and to explore civil rights activism and feminism. I read about what happened in 1968 when Eartha Kitt was invited to the White House by Lady Bird Johnson for the Women Doers' Luncheon, a program the First Lady created for women activists and influencers to discuss topics of the day. There, Kitt spoke out passionately against the war and against racism, declaring that these issues were the driving force behind the much-lamented generation gap. Kitt dared suggest that youths' resistance against government and authority was warranted. Although Kitt had been specifically invited to share her opinion, it turned out to be most unwelcome. She paid a price for being outspoken: the First Lady was humiliated, and later the *New York Times* reported that Kitt had been investigated by the CIA and blacklisted from many venues as a result of the incident. But she was never sorry. As a woman who had lived through hardships on which the First Lady seemed to have little perspective, she knew that her reality deserved to be acknowledged.

As a young girl hearing this story, I treasured my photograph of Kitt dressed in her leopard outfit even more. Some condemned her for being a radical and considered her behavior treasonous, but to me she was on the side of right, not might. She was an authentic role model on every level. Eartha Kitt, I discovered, was not just a woman of style, but a woman of substance, too.

I'll always remember what I learned from her: to live with honor, one must be fierce, and, to this day, leopard print continues to be an emblem of fabulous, intelligent women everywhere. Oh, I believe.

WHAT IS LEOPARD PRINT?

AS FAR AS I'M CONCERNED,
LEOPARD IS A NEUTRAL.

—Jenna Lyons

"Leopard print" isn't in the dictionary. Perhaps some would argue that, since "leopard" is merely a modifier for "print," the phrase doesn't qualify for its own entry any more than "black lace." Still, there are listings for "French seam" and "polka dot" and "tube sock," so why no entry for one of the most distinctive fashion phenomena of the twentieth and twenty-first centuries? The combination of these two words is uniquely evocative. Any lover (or hater, certainly) of leopard print knows that it's so much more than just a print. It's a statement, a symbol, and an implication. The dictionary almost always lags behind slang and terms of popular culture, yet this excuse fails to satisfy when they've had so much time to pick up on it. After all, the phrase "cat café" was added to the Oxford Dictionaries in 2015. And when was the last time you saw a cat café? As recently as the last time you saw leopard print? The author rests her case.

Since Wikipedia is crowdsourced, it should do a better job of reflecting current popular words and phrases. Yet a search for "leopard print" redirects to an entry for "animal print," which includes all kinds of animals—big cats, yes, but also monkeys and zebras and giraffes. The patterns of big cats deserve a special place. Zebras, while stunning, are not ferocious. Leopards are apex predators, which means they are at the top of the animal food chain. The desire to dress like a dangerous animal has

a specific intention to it that simply dressing like a pretty animal doesn't convey. Those who choose to wear leopard print may not mean to say that they are predators, but they are definitely saying they are not prey. The print expresses the power they feel within or makes them feel armored against the power they may lack. Its impact is rooted in nature. It's a vivid form of nonverbal communication.

Urban Dictionary is a completely informal source of definitions, intended to help keep up with ever-changing slang. Anyone can upload a word or a phrase and a definition for it, and readers vote on whether they concur with the definitions. It's a sophisticated and millennial way of agreeing on the terms of communication, but it's very much the Wild West version of a dictionary, much less carefully overseen than a traditional dictionary, or even Wikipedia. No authority denies its definitions. The site's top two definitions for leopard print contradict each other: One implies that animal print accessories are the province of ladies of the evening, a flattering assertion, though not accurate; plenty of sex workers get along without it, while people in just about every job often have a touch of it somewhere in their wardrobe. A completely different take on the meaning follows immediately thereafter—that being the nature of the Internet—claiming that leopard print is the pattern of "a single or divorced woman 35–55, intelligent, successful . . . far, far classier than the trashy 'cougar.'" (See Chapter Nine for more on "cougars.") So, according to the ultra-fresh culture of Urban Dictionary, leopard print is a marker of either sex work or/and mature feminine sophistication. However, while sex workers and sophisticated older ladies certainly have made their imprints on fashion over the years, there are people in every walk of life who wear the pattern, so it's not truly a reasonable indicator of one's job or age. Not satisfied with such a narrow definition, this author had her way with it. As of this writing, Urban Dictionary's top definition is "a pattern that helps animals blend in and humans stand out." Whether the phrase is formally accepted into the dictionary or not, one thing is certain: Leopard print is not going anywhere. The pattern packs too powerful a punch to the eye. Everyone—from the most prestigious designers in the world to the most affordable chain stores—acknowledges the

print's unique value. One fashion designer after another claims it as their "signature print," and it certainly is a signifier. Popular memes declare that "leopard print goes with everything" and that it's a neutral. Though technically true, since the term "neutral" often refers to shades of brown and black, it is clearly a controversial neutral.

The human pupil dilates at the sight of a predator, a primal physical response that's similar for both fear and arousal. Leopard print evolved in nature to help the cats fade into their surroundings as they survey their prey. Through the alchemy of fashion, it both retains its power and tweaks its origins. People who wear leopard print aren't afraid to make themselves visible. They wear it to stand out, not to blend in. They wear it to feel cultured and to simultaneously make a connection to nature. They wear it to entertain, to draw attention, to be noticed. They wear it to appear seductive, purposeful, luxurious, dangerous, and playful. It evokes both nocturnal intimacy and the lush outdoors. It refers to both the danger and innocence of nature. People speak of it with delight or disgust, but no one can simply ignore it.

A group of models poses luxuriously in leopard print, 1953. The faceless man in the background holds a whip, but he clearly doesn't have a hope of mastering these ferocious women.

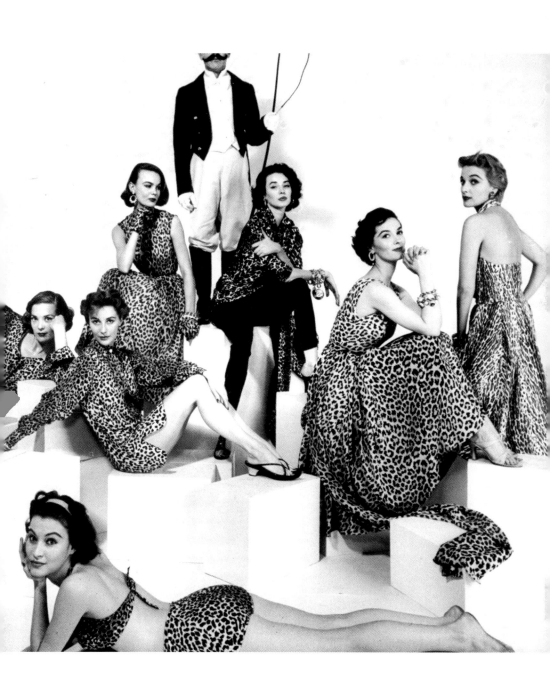

Importantly, the phrase often also applies to patterns other than that of the actual leopard, including those for the snow leopard, clouded leopard, jaguar, ocelot, lynx, bobcat, and sometimes even tiger. For the purposes of this book, however, we will refer to all big-cat patterns—whether printed, woven into fabric, embroidered, painted, and even on genuine fur—as "leopard print," because the phrase is used that way in popular culture and media. Even more specifically, we will look at how these patterns have been employed in garments, particularly, though not solely, those worn by women.

Leopard print has become associated with taking pleasure in makeup and dress.

In spite of the dictionary failing us, observing how leopard patterns have been worn tells us that leopard print is much, much more than the pattern of a leopard pelt imprinted onto fabric. The combination of "leopard" and "print" creates a whole far greater than the sum of its parts. The crowd-sourced definitions from Wikipedia, the potent feminine implications suggested at Urban Dictionary, and the mix of patterns found in the marketplace indicate an identity sought by the wearer as well as a cultural imperative around the phrase "leopard print." It has an impact and a meaning beyond both its literal and figurative definitions. Over the past century, it has become more than merely the description of a pattern, but the name of a marketing term (used to call attention to patterns with which it is often confused), a fashion phenomenon, and a signifier of some kind of coded female presentation.

The way we wear the print these days in popular Western fashion hasn't always had this impact, and people haven't always had the freedom to wear it as they do now. How did this pattern come to have so many meanings? What is the origin of this phenomenon? What does it say about the culture in which this occurs and those who wear it? And who wore it first?

Any LOVER
(or hater, certainly)
of LEOPARD
print knows that it's
so much MORE than
just a print.
It's a statement,
a SYMBOL, and an
implication.

WHO WORE IT FIRST?

I COPIED THE DRESS OF AN ANIMAL
BECAUSE I LOVE TO COPY GOD. I THINK GOD IS
THE MOST FANTASTIC DESIGNER.

—**Roberto Cavalli**

Opposite page: What cat is that? From top to bottom: leopard, jaguar, cheetah, ocelot, clouded leopard, bobcat, snow leopard, and black panther.

L eopards have always worn leopard print. It was nature before it was culture. An Internet image search for "leopard print" reveals a variety of patterns. The spots may be solid or have a gold center; they may be small dots encircled by larger dots; they may be elongated; they may even be gray. Some of these patterns are leopard print, and some aren't. The leopard may be the most recognized spotted cat, but it is far from being the only one.

Among the prints called leopard are the patterns of other equally fabulous felines, such as cheetahs, jaguars, and ocelots. They are the fashion leaders for the phenomenon of leopard print. Their beauty, along with their power, adaptability, and ferociousness set a standard well worth emulating. Humans, as the only animal to cover its skin, look to nature to inspire culture. The wearers of these prints show their intention to be brave and powerful and the choice to wear the pattern of ferocious felines makes a clear statement.

Being able to tell these patterns apart and learning about the cats that wear them helps explain their universal appeal. Many of the details are surprising, especially for those who may have thought that all these cats are variations of a single species or that they all hail from the same country or continent. Once you've learned to spot the differences, the animal kingdom will never look the same again.

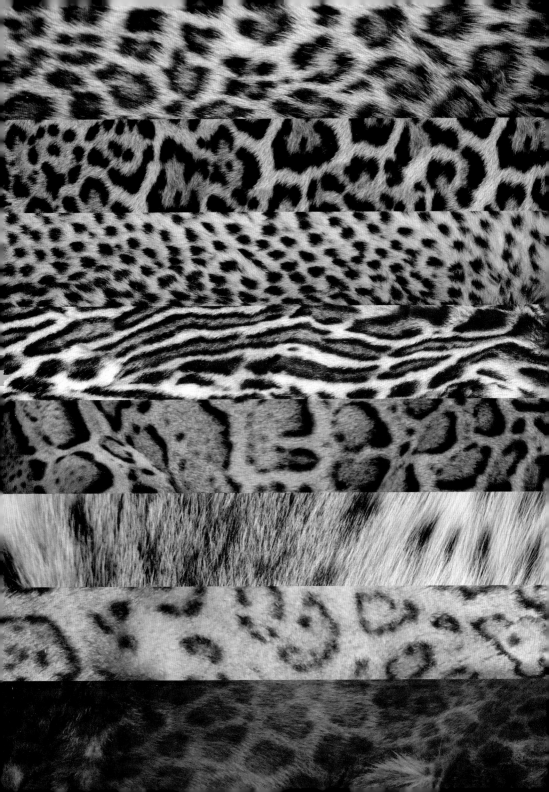

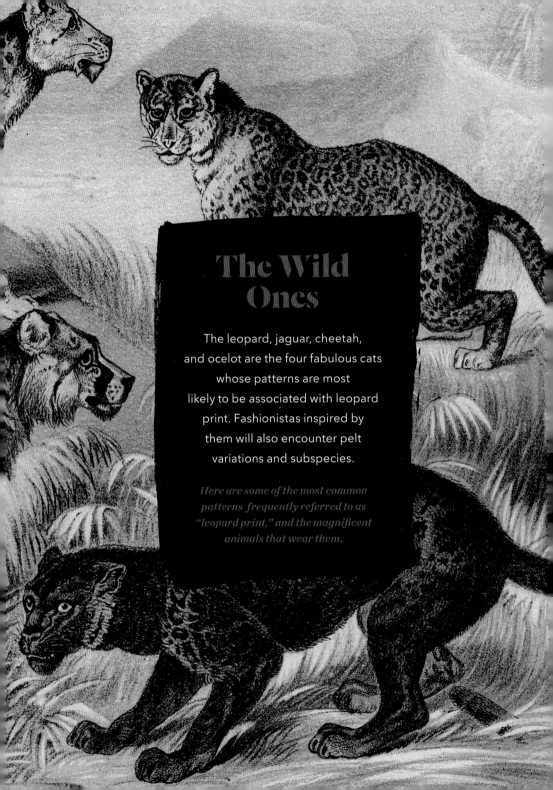

The Wild Ones

The leopard, jaguar, cheetah, and ocelot are the four fabulous cats whose patterns are most likely to be associated with leopard print. Fashionistas inspired by them will also encounter pelt variations and subspecies.

Here are some of the most common patterns frequently referred to as "leopard print," and the magnificent animals that wear them.

/ *Note* /

The International Union for Conservation of Nature Red List (also known as the IUCN Red List) is the world's most comprehensive register of the global conservation status of biological species. The list classifies species into the following nine groups:

EXTINCT

No known individuals remaining

EXTINCT IN THE WILD

Known only to survive in captivity or as a naturalized population outside its historic range

CRITICALLY ENDANGERED

Extremely high risk of extinction in the wild

ENDANGERED

Very high risk of extinction in the wild

VULNERABLE

High risk of extinction in the wild

NEAR THREATENED

Likely to become endangered in the near future

LEAST CONCERN

Lowest risk

DATA DEFICIENT

Not enough data to make an assessment of its risk of extinction

NOT EVALUATED

Has not yet been evaluated against the criteria

Leopard

PANTHERA PARDUS

International Union for Conservation of Nature status:

/ *Vulnerable* /

The leopard is one of nature's great beauties. Its legendary coat is distinguished by broken black circles, which zoologists have romantically labeled "rosettes," on a cream to golden background. The circles are filled with a darker shade of gold, and over the leopard's belly, legs, and head, the pattern graduates into more solid spots on lighter-colored fur. The rosettes are typically more circular on African leopards, and larger on Asian leopards. The coat is an evolutionary adaptation to the shadow-dappled environments of jungles, forests, and water.

The leopard is most commonly found roaming Africa, Asia, and the Middle East, though it can still be found scattered in parts of Eastern Europe. As one of the "great cats," a nonscientific term encompassing the four largest members of the genus *Panthera*—tigers, lions, jaguars, and leopards—the leopard has the ability to roar, a specific vocalization not shared by any other felines outside of these four. Spectacularly powerful, it's able to run at speeds up to thirty-five miles per hour, and can climb trees while carrying up to three times its own body weight.

Jaguar

PANTHERA ONCA

International Union for Conservation of Nature status:

/ Near Threatened /

Another of the four "great cats," the jaguar is a distinct species often confused with the leopard. The jaguar is very much its own cat. Its coat features larger, more angular spots, which, unlike a leopard's, have additional black markings inside some of the rosettes. More massive than the leopard, the jaguar shares its adaptability to various habitats, though it is indigenous to the jungles of Central and South America. It was once common in Mexico, where it can still be found in lower numbers, and occasionally ranges as far north as the southwestern United States. Its preferred habitat is dense rain forest, and it's an avid swimmer. Although protected from trade, the jaguar remains vulnerable to ranchers and farmers, who may kill it illegally to protect their livestock.

Cheetah

ACINONYX JUBATUS

International Union for Conservation of Nature status:

/ *Vulnerable* /

The cheetah hunts by day, while the leopard hunts by night. Its coat, evolved in nature to help it blend in with long grasses, features a pattern of solid black spots distinctly smaller and closer together than those of the leopard or jaguar, with a lighter gold background. The cheetah occupies some of the same geographic territory as the leopard in Africa and Asia and is currently being reintroduced in India. The cheetah is famous for its remarkable speed, which enables it to sprint up to its prey. Unlike the four great cats, she cannot roar. Her distinctive vocalization includes chirps and mews.

Ocelot

LEOPARDUS PARDALIS

International Union for Conservation of Nature status:

/ *Least Concern* /

The ocelot, like the jaguar, is native to the Americas. Its pattern is distinguished from the leopard's and the jaguar's by dramatic elongated oval rosettes along its spine and sides. Like its distant cousin the cheetah, the ocelot has black tear lines running from the inside corners of its eyes down to its muzzle, giving it a look of great sensitivity. Highly adaptable, the ocelot is found both in deserts and along rivers, ranging from Central and South America to Texas and Arizona in North America. It is significantly smaller than the other cats profiled here, with a weight range of eighteen to forty pounds, compared to the leopard's range of eighty to two hundred.

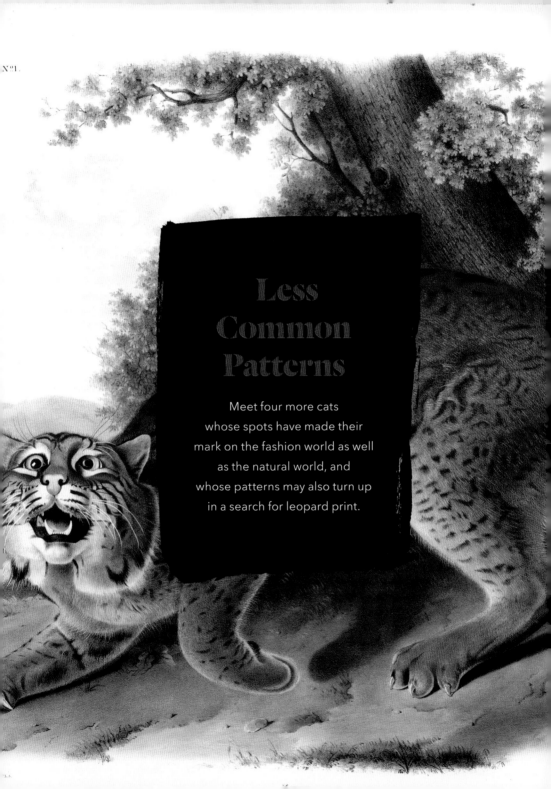

Less Common Patterns

Meet four more cats
whose spots have made their
mark on the fashion world as well
as the natural world, and
whose patterns may also turn up
in a search for leopard print.

Lynx

LYNX CANADENSIS

International Union for Conservation of Nature status:

/ *Least Concern* /

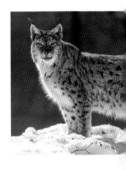

The lynx is best known for its stylish ruff, tufted ears, and short tail. Although it doesn't always have a pattern on its coat, when it does, the pattern is off-white to tan, with small dark brown or black spots. The lynx family is found in Europe, Asia, and the Middle East, and is also common in southern Canada, the United States, and Mexico. Though comfortable in the snow, the lynx prefers more temperate zones. The national animal of Macedonia and Romania, its pattern is frequently featured on faux fur coats often marketed as a version of leopard print.

Irbis (Felis Irb

Snow Leopard

PANTHERA UNCIA

International Union for Conservation of Nature status:

/ *Vulnerable* /

The snow leopard, also known as the ounce, is aptly named, both for its coloration and its preferred habitat. Its fur is long and thick, white to pale beige, marked with black or gray rosettes. Its eye color is gray to pale green, rare among large cats. The snow leopard's tail is exceptionally long to help it balance while walking among the mountain ranges it prefers. The snow leopard ranges from Siberia in the Kunlun Mountains throughout the Altai Mountains, the Himalayas, and into Tibet. Among the cats, the snow leopard has the greatest preference for cold and, during warm weather, retreats into the alpine zone.

Clouded Leopard

NEOFELIS NEBULOSA

International Union for Conservation of Nature status:

/ *Vulnerable* /

The clouded leopard is another cat that adores the mountains. Its coat is gray to tan and is distinguished by large, angular spots that fade from their black edges into a dark gray center. This pattern can be mistaken for that of a giraffe's. The clouded leopard lives in the Himalayan foothills and ranges from Southeast Asia into China. Though believed by nineteenth-century zoologists to be extinct in Nepal, the clouded leopard has been rediscovered there, and its future looks optimistic.

Black Panther

The black panther has no taxonomy because it's not a separate species of cat. The so-called black panther is, in fact, a jaguar or leopard that is melanistic and appears from a distance or in low light to be solid black. In sunlight, the pattern of black rosettes is visible on dark coffee-brown fur. The black leopard variation is caused by a recessive gene and is born into litters with both the standard gold and dark variations. The jaguar color variation is caused by an inherited dominant gene. Their range is the same as their standard-colored counterparts.

FIT FOR A GODDESS

WITHOUT ANIMAL PRINT THERE COULD
BE NO DIVAS, OR EVEN DIVINITIES.

—Dolce & Gabbana, *Animal*

One of the earliest examples of a woman of power associated with great cats is the *Seated Woman of Çatalhöyük*. Discovered in an archaeological dig in 1961 and dated circa 6000 BC, she is a clay figurine approximately eight inches tall depicting a nude woman seated on a stool. She is fully fashioned and full-figured from every angle, with gloriously pendulous breasts and voluptuous rolls of fat on her belly and back. Some archaeologists have postulated that she's giving birth—a child's head appears to be emerging from between her legs. Each of her hands rests, as if upon the arm of a throne, upon the head of a leopard. The figure is dynamic, emanating abundance, assurance, and authority.

Çatalhöyük, located in present-day Turkey, is one of the world's oldest known urban civilizations, a preliterate but sophisticated city filled with the signs of community and human innovation: collective homes, cooking implements, painted murals. It appears to have had no particular hierarchy and no particular activities associated with gender roles.

The figurine is clearly a symbol of the good life. She is the fertile source of all things. The leopards appear to be her companions in power, both protecting and being protected by her, echoing her calm assertion that the space she inhabits is hers to command. The leopards are dangerous, but not to her. The trio's combined inherent strength allows them

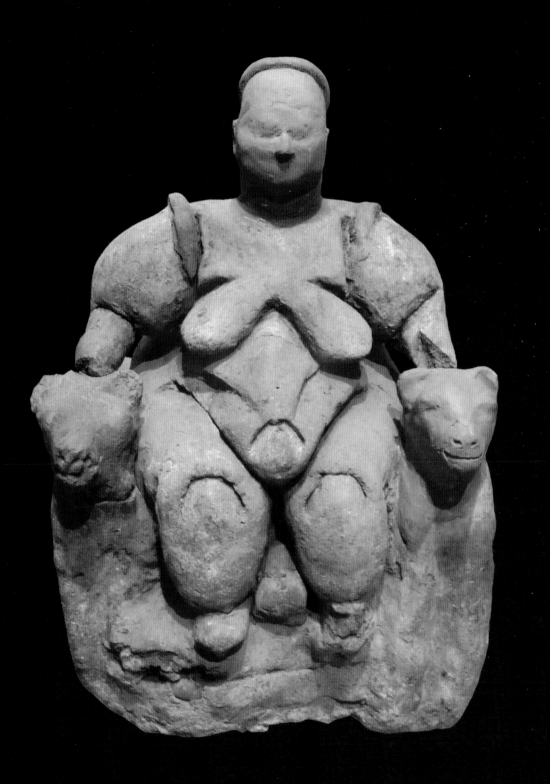

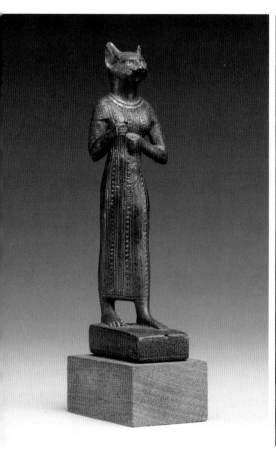

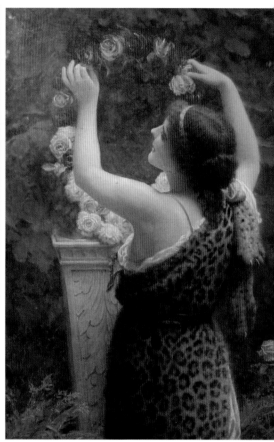

to wait serenely, as if expecting an audience of supplicants whose needs they can surely meet. She represents bounty itself in the form of nature's provisions. These leopards, neither garments nor accessories, make the association between humans and animals as collaborators, in keeping with many prehistorical, historical, and present spiritual and social practices.

For most of history, the patterned cats have been associated with power: supernatural, spiritual, social, economic, or political. Cats of every size appear in the histories and mythologies of cultures around the world. Egypt had many: cat-goddess Bastet, who had her own cult and temple; lion-headed Sekhmet, goddess of fire, war, and dance, who appears in temple art in dynasties dating back to 2500 BC; and Seshat, who was depicted wearing a leopard gown similar to the drapes and full pelts traditionally worn by Egyptian funerary priests, and was the goddess of wisdom, knowledge, and writing.

Ancient Greek mythology tells of warriors dressed in leopard skins, including Amazonian women warriors; an ancient Greek vase shows Achilles spearing Penthesilea, one such Amazonian warrior he could defeat only due to his impenetrable skin. As he killed her, he fell in love with her and was tortured by grief at her death. Even after death, the woman in leopard skin held power over one of the greatest heroes in Greek literature and mythology. Shiva, one of the three supreme gods of the Hindu pantheon, is frequently depicted wearing tiger or cheetah skin. Chinese mythology's Xi Wangmu, the Queen Mother of the West, was a ferocious goddess with the teeth of a tiger and the tail of a leopard, and in the Chinese zodiac, every twelfth year is the Year of the Tiger.

Many pre-Columbian empires featured jaguars and ocelots in their spiritual iconographies; Aztec goddess Tlazolteotl, who purified sinners after sexual misdeeds, was associated with the ocelot *trecena* (one of the segments of the Aztec calendar system), and the Mayan Waterlily jaguar represented a swimming jaguar, which was a source of fertility. Some Native American nations identify the bobcat as keeper of secrets, a warning omen, or a protector. The Bible mentions both lions and leopards as allied to supernatural forces. Gayomart, the first human in the

Opposite page, left: Egyptian goddess Bastet, who had her own temple, represents the adoration of cats in this figurine dating from 664 to 30 BCE.

Opposite page, right: Eighteenth- and nineteenth-century portraitists demonstrated their admiration for the classical arts by draping leopard skins on the shoulders of soldiers and high-status women in their paintings, as in this late-1800s painting by Charles Perugini.

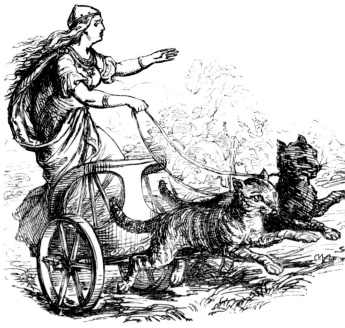

Left: Chinese goddess Xi Wangmu, recorded at least as far back as 1500 BCE. She is sometimes depicted with a tiger's features or with a leopard's tail.

Right: The Norse Goddess Freyja had cats leading her chariot and sometimes transformed into them. Freya was the goddess of love and erotic passion.

Zoroastrian mythology, is portrayed as producing the first male and female couple, and is pictured in an illuminated manuscript wearing a leopard suit while doing so.

Domestic cats appear in mythologies other than the Egyptian; Norse goddess Freyja, emblematic of fertility, beauty, and luxury, rode in a chariot led by two cats. Black cats appear in children's stories as the familiars of witches and evoke the crone or wisewoman archetype, and their persecution in real life was representative of a fear of feminine power. These are just a few examples of the worldwide impact of cats large and small on the human spirit and psyche.

The big cats are inspiring not just for their beauty, but also for their adaptability to many environments. Leopards are at home sleeping in trees, swimming in rivers, and roaming the jungle floor and the

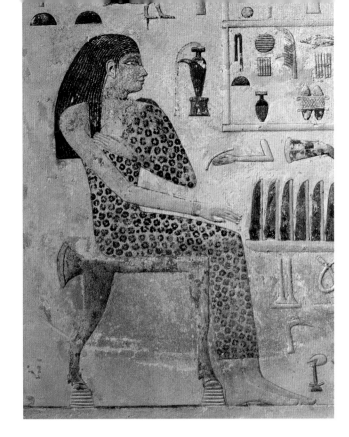

A painting on limestone shows Egyptian Priestess Nefertiabet draped in leopard from her tomb at Giza (dated 2590–2565). Priests and priestesses in Ancient Egypt are often pictured in leopard skins and garments. Priests were close counsel to the pharaohs, and were sometimes blood relatives of the royal family. The pharaoh could be called "The High Priest of Every Temple."

arid desert. They tend to be solitary except when breeding and nurturing their young. Big cats are also apex predators, which means the only creatures that actively prey on them are other great cats or humans. It makes sense that the impulse to honor, emulate, and often to master these animals is universal wherever they are known.

However, the worship of these animals has not in any way inhibited many human societies from also keeping them as pets, hunting them, or wearing them.

Plants and animals have been fashioned into adornment and clothing by people on every continent, in every era of human culture since the earliest days of human history. Plants, especially grasses, were often woven into textiles, and drapes were made from furs. In warm climates, less clothing was worn, but there has always been some form

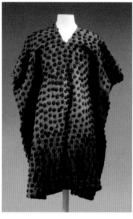

Top: An Aztec jaguar warrior of high rank, as portrayed in the Codex Magliabechiano.

Bottom: This nineteenth century African sisal tunic is embroidered with hair to evoke a leopard pattern. Leopard fur has long been a symbol of status, authority, ceremony, and pride in many parts of Africa. It has been referenced on textiles there for millennia, often stylized in geometric forms.

of adornment—a belt or piece(s) of jewelry, for example—that featured seashells, feathers, and teeth as well as textiles and furs. People of the world got to know one another—sometimes willingly, sometimes by force—by traveling to trade the nature and culture of their homes with other regions. Jewelry, textiles, and furs, in particular, have driven international trade for millennia.

Various articles of clothing have assumed meanings both within and outside of their cultures. Fashion is a language of sorts, a way to express and communicate personality and status. This kind of sartorial language includes many more signifiers than just leopard print, of course. As soon as humans began wearing garments, they began assigning meaning to every aspect of them. In *Clothing: A Global History*, historian Robert Ross notes that gender is particularly signified: "It is hard," he wrote, "to conceive of an outfit worn by an adult, anywhere in the world and at any time, which does not in some way, blatantly or subtly, pronounce the gender of its wearer." As we'll see, while both gods and goddesses have been associated with both wild and domestic cats, a human's wearing of the pattern has gone from being associated more with masculinity to being associated with femininity, especially in Western cultures.

The language of clothing speaks from different styles, fabrics, and colors for different levels of authority; delineates status and hierarchy in both formal and informal social situations; and reserves certain articles of clothing for military, spiritual, or other official and authoritative functions. Fur, in particular, has been used to signify wealth, nobility, and power, whether personal, political, or both, wherever they occur. Honoring and serving royalty has often been claimed by royalty to be their subjects' spiritual imperative, since the royals'

power, at least when it is inherited through blood relations, is divine, and the priests and warriors who preserve their power have often worn leopard or jaguar skin.

Clothing can make such an important statement of status that people in power have often attempted to control who wears what. People in power, from the ancient king with his royal edict to the modern high school mean girl with her sneer, can punish those who wear particular colors or accessories, whether because they reserve them for themselves or deem them immoral or unsightly. When necessary, those in charge will make it part of religion and rituals in order to maintain their power as a moral imperative.

Sumptuary laws have historically regulated much more than dress; they are, among other things, laws imposed to keep citizens from assuming the appearance and lifestyles of royalty. They have appeared in societies throughout the world and are, generally speaking, a way of trying to keep people in their places. Rulers might claim they were trying to

Fashion is a LANGUAGE of sorts.

protect people from their own propensity to consume beyond their means (not unlike austerity measures), but they often served as a form of enforced class distinctions, focused as they were on visible displays of luxury. Before the Middle Ages, luxury and indulgence were considered immoral by many civilizations, but that rarely kept their rich and powerful from indulging.

Both official and unofficial sumptuary laws varied from culture to culture in ways that could be confusing, and would certainly be difficult for a time traveler to keep in mind if he or she wanted to blend in. In ancient Greece, only courtesans could wear garments with a gold or purple border; ancient Romans, on the other hand, reserved gold and purple for rulers. The use of expensive dyes, trims, and fabrics could signify either honor and power, or excess and immorality, depending on who was wearing these items, where they were wearing them, when, and who was looking at them. Such contradictory and shifting

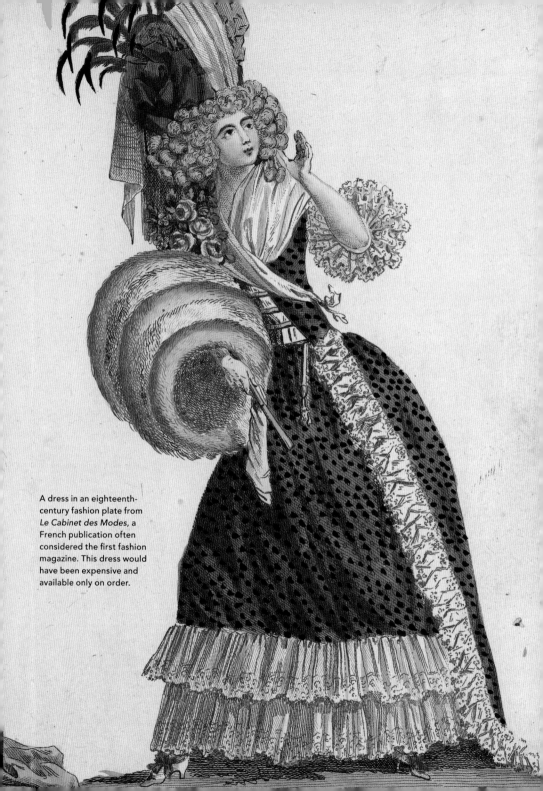

A dress in an eighteenth-century fashion plate from *Le Cabinet des Modes*, a French publication often considered the first fashion magazine. This dress would have been expensive and available only on order.

meanings of what is appropriate to wear, when, and by whom, continue to be important, and are sometimes a matter of life and death even in our supposedly modern times.

Fur has been just one of the many types of garments regulated in these ways. Of course, everywhere big cats have been known, wearing their pelts and patterns has had meaning, and those meanings always relate to the characteristics of the animals themselves—ferocity, strength, and adaptability—as well as to the cultures in which they are worn. To wear a leopard skin often meant that one was a mighty warrior or hunter, and in many societies only people who had killed the animals, at great risk to themselves, had the right to wear the fur—unless they were royal, in which case warriors and hunters might present the pelts to their leaders as offerings of loyalty. While the fur trade came to be a prime mover of international trade, it wasn't until the 1600s that intercontinental trade became more common.

Sartorial restrictions tend to pass and many of the ancient ones have vanished in much of the Western world, except for legally regulated uniforms such as those worn by the military and the police. No one worries much about royalty today. However, the natural impulses behind the ways leopard fur and leopard print were worn before civilians and commoners had access to them still inform the way people wear them in the twenty-first century.

Of particular note in the Western world, European royalty and nobility wore spotted ermine furs for centuries. Queen Elizabeth II wore an ermine cape to her 1953 coronation. The ermine is a kind of mink, a small animal, so it took many ermines to make the fur linings of their coats and trims. (Although they are white, their black-tipped tails provide the spotted effect.) The larger pelts of great spotted cats, particularly lynx and leopard, from Eastern Europe and Asia, became a status symbol for nobility and were often worn on the shoulders of generals and on the saddles of great military men. The fur evoked worldliness as well as both physical strength and political influence. Spotted animals continued to be associated with this status for centuries, and lynx and leopard, which at the time were much more populous in Eastern Europe than they are now, naturally found their way into the closets of royalty.

The wealthy class of eighteenth century Western Europe had a penchant for ancient cultures, particularly Greek and Roman, believing that classical art and philosophy were the primary signs of intellect and depth. Women in portraits often appeared dressed as the goddesses draped in the precious pelts that they saw on Greek vases. (The urge to feel like a goddess was a strong motivator for wearing leopard, and this can be seen often in paintings of the belle epoque era.) Fur, no longer simply draped, was cut, sewn, and shaped in more sophisticated ways. Its importance as protection from the elements and as a symbol of status or wealth did not wane, but it was used ever more creatively.

The first time the print, as opposed to the fur, made a significant appearance in Western fashion was in the eighteenth-century illustrations of the infamous macaroni. The macaronis were mid- to late-eighteenth-century wealthy, world-traveled young men who devoted themselves to elaborate fashion. Because they were so fancy, they were often mocked for their androgyny, but they looked divine. In the song "Yankee Doodle," when the British sang "stuck a feather in his hat and called it macaroni," they were mocking Americans for their lack of sophistication and style. Furthermore, because cats were often found in the home, specifically in more "women-centric" areas such as the kitchen, the association with cat prints was seen by some as effeminate. Adherents of this male fashion trend in the late 1770s wore deliberately flamboyant clothing covered with rich fabric, embroideries, and laces, as well as enormous wigs, which were often mocked by less wealthy or more conservative people. They were resisting sober authority and the wave of respectability in fashion. Their styles influenced the French aristocracy and the leopard pattern began to be embroidered or woven into fabrics worn by the more idle and indulgent rich. They were thought of as clearly not serious businesspeople or politicians, and the print was associated with a kind of frivolous sophistication and worldliness. Those who weren't well-to-do generally owned very few articles of clothing and rarely thought of clothes as a form of expression. Pamphlets and fashion plates were circulated to more resentment than envy. A cartoon of the time shows a wealthy man at a matinee, petting a woman with

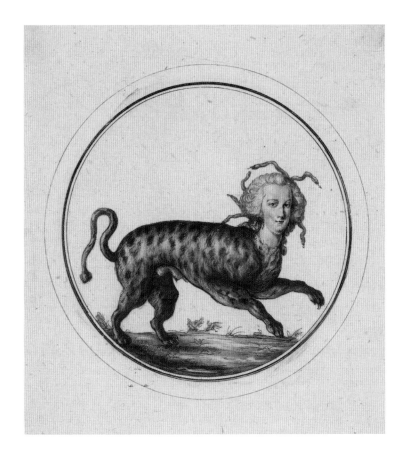

By the time of the French Revolution, Marie Antoinette was no longer dressing in an extravagant style, but she continued to be vilified for her previous standard of living after she attempted to escape the revolution with her husband, Louis XVI. This flyer, intended to point out that she was unable to change her spots, would have been distributed among the people, and was designed to mock her attempt to evade the revolution.

leopard-patterned trim on her dress. The implication was of deliberately over-the-top indulgence and dissipation. The more outrageous women of the French courts adopted the style.

Neither seated nobility nor peasants were likely to wear leopard print, but it certainly had its heyday before the French Revolution and the rebellion that toppled many of these aristocrats from power, along with their heads. It wasn't, however, the French Revolution that made the print available to every woman, but the Industrial Revolution.

HATSHEPSUT

Hatshepsut was one of only a few recorded female rulers of ancient Egypt (1507–1458 BC), and was widely considered to be one of the most accomplished pharaohs of all time. She began her career as a priestess of Amun and was the chief wife in the harem of Thutmose II, who was the son by a different mother of her father Thutmose I. During this era, pharaohs kept harems of wives partly because the mortality rate for infants was incredibly high. They also often intermarried to keep the bloodline pure. Hatshepsut originally ruled jointly with Thutmose III, the son of another of Thutmose II's wives, as co-regent, because he ascended to the throne at the age of two.

She reigned for approximately twenty-two years and was one of the most prolific builders of ancient Egypt. She directed hundreds of projects across all of Egypt, so many that some later pharaohs tried to claim her work as their own. She is known for building the Temple of Pakhet, the lioness and huntress goddess known as She Who Scratches, who protected both living and dead from evil, at Beni Hasan. She was also responsible for establishing important trade routes that increased the wealth of Egypt exponentially.

She also commissioned art that celebrated her accomplishments. Early in her co-reign with Thutmose III, she had herself depicted, as was common for women in those days, dressed in long fitted robes, and with golden skin. However, as Thutmose III grew older and closer to being able to assume power, she began to have herself portrayed in the clothing of pharaohs, with shorter skirts and a more masculine body as well as with the beard of a pharaoh and the shade of copper skin commonly used in paintings of male figures. Some Egyptologists speculate that ancient Egyptians may have believed that women had to become men to gain entrance to the afterlife, after which they could resume their female form. Because female pharaohs were rare, Hatshepsut's

choice of depiction may have been a measure to protect her power in life as well as to secure her place in the afterlife.

Her work as a priestess most likely continued during her reign. Priests and priestesses of her time often wore leopard gowns and leopard fur drapings, and Hatshepsut clearly continued to identify with the leopard motif as seen in this senet game piece attributed to her for her own use in play, and signed with her insignia. It retains both the feminine priestess role and the red of the male stature required to ascend to the heavens, and is a perfect symbol for one of the most powerful women in history.

MACHINERY & MODERN WOMEN

YOU HAVE TO HAVE COURAGE
TO WEAR LEOPARD.

—Rachel Zoe

The twenty-first-century woman in leopard print is the culmination of thousands of years of international trade and cultural exchange, voluntary and involuntary, accelerated in recent centuries by the waves of rapid advancement in technological development starting with the Industrial Revolution. Her access to fashion is the result of an unprecedented wealth of options combined with a historically unique freedom of choice to select from among these options. Before leopard print could become the global phenomenon it is today, the garment industry had to evolve—and women had to take matters into their own hands in more ways than one. The fierceness women display by wearing leopard print was rising even before the pattern was generally available. Some of these women weren't wearing leopard print, but we wouldn't be wearing it without them, and in time it would become one of the expressions of a woman's right to move about and dress as she pleased.

In the thousand years between Princess Nefertiabet and Hatshepsut, the changes in ancient Egyptian clothing were minor compared to the differences in Western fashion between 1880 and 1920. The ancient Egyptian fitted gowns, decoration, and even the wigs of each era look similar to the untrained eye, but even someone unfamiliar with Western fashion would immediately be able to tell the difference between a Victorian woman in her bustle and bouffant and a flapper in her beaded chemise and bobbed hair.

Most ancient cultures have left records of an interest in fashion, and the art of various times displays each of their distinctive styles. Most fashion laypeople can easily recognize the difference between classical Greek robes and a traditional Japanese kimono, for instance, but within those cultures fashion didn't change drastically every year, and methods of garment production didn't vary between one decade and another as greatly as in the past few hundred years. Before that, fashion would change when a new regime assumed authority, when a new culture was encountered and emulated or plundered, or a new dye or textile was introduced. This did not happen continuously, as it does now. Today, we are constantly informed about other regions and cultures; we have media that introduces new fashion to us daily, without the delays of fashion-plate production and distribution; we have technology that mass-produces a style within days of its design; and we have trains and planes to get that fashion to us immediately, and cars to drive to stores and trunks in those cars to load up with new stuff. It would be foolish to assume that the world was primitive and unsophisticated before modern technology, but there is no doubt that it was much, much slower.

Looking at a timeline of Western fashion, it's easy to see changes in clothing beginning to occur at exponentially faster rates in Europe and the Americas in the eighteenth century. The difference in shape between Marie Antoinette's lavish gowns with corsets and panniers, worn with enormous wigs, is remarkable compared to the light gowns and more naturalistic updo hairstyles of Napoleon's courts, less than a generation later. Of course, few of Marie Antoinette's subjects could have afforded the lavish styles of her court, which was her ultimate problem, as they beheaded her in their rage about the unequal distribution of wealth. Her wealth and sense of fashion was advertised and mocked in leaflets distributed widely, and was to many a source of resentment rather than of admiration. The constant flaunting of luxury and ease was unbearable to the poor, who made up the bulk of the French nation when she was queen. With no chance to enter the nobility and no promise of upward mobility, fashion was of considerably less interest to them than revolution. In fact, some revolutionaries would kill people who dressed richly,

and dressing down became a matter not only of pride but also of safety, where previously a wealthy person's clothing protected them and made them admirable and untouchable. The appearance of leopard patterns on the gowns of her ladies and the pants of her lords was of note to the revolutionaries only insofar as they could mock it. Though she never actually said, "Let them eat cake," no one as hungry for bread as her subjects missed the insensitivity of nobility using flour commoners could not afford to whiten their expensive wigs.

The simpler clothing and the absence of wigs in Napoleon's court did not, however, reflect a sensitivity to his subjects' needs, so much as a desire to reflect the aesthetics of the classical empire. Napoleon's hair was styled after the short hair of Roman senators and conquerors such as Caesar and Alexander the Great, and his generals trimmed their saddles and clothes with leopard fur inspired by warriors in classical art and literature. Of course, Napoleon's empire tumbled, as did Marie Antoinette's head, but not before a great deal of expansion.

In the past, the choice of whether to wear fancy clothing simply wasn't available to anyone besides the powerful, the rich, and sometimes entertainers. Sumptuary laws were intended to keep people in their places, but most people were too poor or too rural to be affected by them.

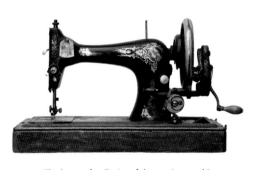

The homey familiarity of the sewing machine belies its importance as an agent of massive change to worldwide trade and labor.

Throughout most of history, clothing—each individual garment, other than military uniforms, which might be made in assembly lines—was made by hand. Textiles were woven by hand, with or without looms, and every stitch was put in place by hand. The techniques were sophisticated, but the technology was simple. Decoration could be fine and detailed, with elaborate appliques and embroidery and beading, and in more recent centuries with seaming and lace. However, it was rare for an individual to own many articles of clothing.

In the eighteenth century, clothing was most often made by the women of the house and, if the family was well-to-do, by the servants.

New clothing wasn't always an imperative. Most people had clothing repaired and bought secondhand—not as we now buy it for its vintage style, but simply for economy.

The Industrial Revolution, between the mid-1700s and the mid-1800s, was a time when huge waves of entrepreneurialism and a plethora of inventions built upon each other and drove the economy and culture of the world to new heights. Major inventions in the garment-production industry changed the way people lived and dressed in the mid-1800s. The sewing machine went through several iterations before a model resembling the current version was patented by Isaac Singer in 1851. This patent was promptly and successfully contested by inventor Elias Howe, who had produced a similar machine shortly before, resulting in Singer having to pay Howe royalties for decades.

The assembly line became a fixture in both sewing machine factories and the commercial garment factories where those sewing machines were used. Originally, modern garment factories were designed to produce military uniforms, not unlike the hand-sewing factories of ancient Roman times, but were quickly adapted to commercial use for the civilian market. Factories not only produced textiles, sewing machines, and clothing, they also provided jobs, particularly for women, which gave them the money and independence to purchase textiles, sewing machines, and clothing.

Sewing machines became available to the masses at a time when the majority of clothing was made or altered at home. They were expensive enough that households often purchased one as an asset jointly owned with others, to be time-shared.

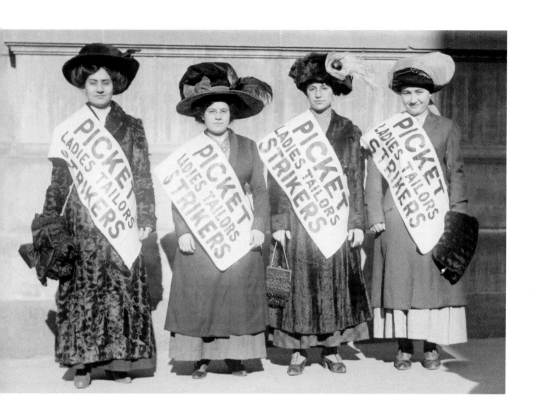

These garment
workers and their
allies fought against
the organized owners
of sweatshops in
New York City.
Today, activism is
still required to make
garment production
safer and more
equitable for workers
throughout the
world.

Workers in the garment-production industries weren't satisfied
with working conditions, however. In New York, sweatshops—places
where employees and contractors were employed for interminable hours
under poor conditions for cruelly low pay—led to a revolution in the new
industrial workforce.

Many of the garment-industry workers in New York were Jewish
immigrants. In parts of Russia, Jews had been forbidden from attend-
ing institutions of higher education—though many of them studied on
their own—and from taking most high-status jobs. Many became mas-
ter tradespeople, particularly seamstresses and tailors. When Jews fled
to America after the violent pogroms following the assassination of Czar

Alexander II in 1881, they arrived with the skills and knowledge of clothing production, and so were naturally drawn to the garment industry. In America, they were not disposed to accept terrible working conditions after all they and their families had already been through. They were a strong, vocal group within the movement in America, and were willing to be part of mobilization efforts for workers' rights.

One of the fiercest activists was Clara Lemlich, a petite woman in her early twenties who was a prime mover in garment-industry reform. She led strikes and fought strike breakers, often in physical confrontations; one headline read, "Girl Strikers Form Band to Fight Thugs." She was arrested seventeen times by the police, who had relationships with the factory owners and their cronies. She helped lead the enormous strike of female garment workers known as the Uprising of the 20,000 and, after the notorious Triangle Shirtwaist Factory fire in 1911, became even more ferocious about forcing employers to provide not just better pay but safer working conditions, too. The International Ladies' Garment Workers' Union she helped foster was part of one of the great feminist movements of the turn of the century.

Women were becoming increasingly vocal. The suffrage movement, which had been interrupted by the Civil War, returned with a vengeance in England and the United States at the end of the nineteenth century.

The clothing manufactured in these factories reflected the changes in a woman's place in society. As women became more mobile in the nineteenth century, they required lighter clothing that was easier to wear.

In the Victorian era of the late 1800s, women were hobbled by everything from unequal laws and moral standards to heavy skirts and other restrictive clothing. A woman of average means would have worn over-the-knee stockings with drawers and a chemise as her first layer; a boned corset over the chemise; a crinoline, which was a cage of steel to support her heavy skirt; a bustle; multiple layers of petticoats; then a camisole; and finally a long dress or heavy skirt suit. If she ventured outdoors, she would have to wear a coat and bonnet to be considered respectable, and in an age where women had few rights or protections, being respectable was more than just a desirable status, it was safety itself.

With all these gigantic garments, one would assume that women had huge walk-in closets. In fact, with the exception of (as always) the well-to-do, most people owned few outfits. Women before the twentieth century did not have the closets and drawers full of clothing that most American women do today. Blueprints of American homes and apartment buildings at the turn of the century show small, shallow closets and, in many cases, none at all. Armoires held their long garments, but anyone who has ever owned an armoire can confirm that they don't hold anything near what many women wear in the course of a week these days.

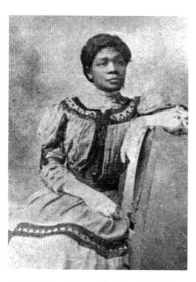

Hattie Redmond was a significant activist for women's suffrage and civil rights in Portland, Oregon. Suffragists sometimes experienced conflicts within their ranks due to class and race relations, but women such as Redmond and Ida B. Wells refused to march in the back of the line.

Because all clothing was handmade, it was slow to acquire as well as expensive. In fact, ruffles were attached to the bottoms of petticoats because it was easier and more affordable to replace them instead of the entire dress when they got dirtied or damaged. Mending and modifying existing clothing was an essential part of maintaining a wardrobe in a time when clothing was not easily replaceable. "Taking in sewing" for extra money became a home industry and revolved around repairing damaged clothing and doing alterations to fit new owners, new trends, or changes in one's body. So, despite the bulky outfits Victorian women wore, because they owned so few items, they didn't think of clothing closets as a priority. It wasn't until the 1940s that home construction began to regularly include the bigger closets that homeowners today take for granted.

After the turn of the century, women became more open about their interest in getting out of the home. Nineteenth-century suffragettes got a taste for the larger world when their activism took them out of the house to organize and participate in temperance actions and marches for women's rights. As more ready-made goods became available, traditional dry goods stores—shops where the merchandise was

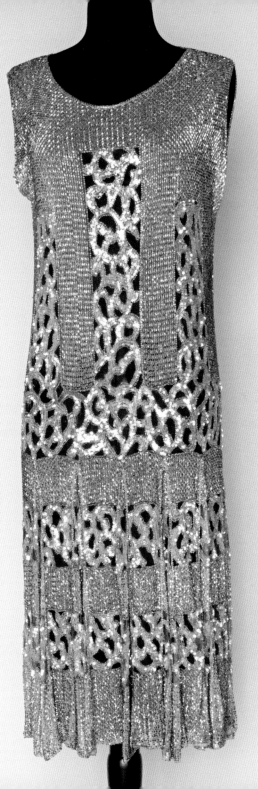

This couture 1920s evening dress sold by Augusta Auctions features beads and sequins that evoke leopard pelts. Flamboyant animal motifs, particularly peacocks and dragonflies, were popular with aficionados of the Beaux-Arts and art nouveau movements. Stylized versions of the motifs made their way into the art deco period.

often stored behind the counter—became more like modern department stores. There, women could shop, socialize, and speak more freely than they could in church, which was often the primary center of their lives outside the home. They could enter these stores at will, without having to buy anything at all.

They were also getting around on a newfangled contraption called a bicycle. While the two-wheeled machine had gone through several incarnations, in the nineteenth century a more practical and mass-producible version became available, with a pedaled iteration patented in the United States in 1866 by a Frenchman named Pierre Lallement. Improvements in street surfaces made the bicycle more practical both for transportation and for recreation. The new woman of the 1890s, one who worked outside the home, often used a bicycle to get around, and she needed lighter clothing to ride it. Clothing became more conducive to movement, and flowing skirts and shirtwaists factory-produced in New York City became popular. Susan B. Anthony praised the emancipation that women had as a direct result of the two-wheeler. Furthermore, the automobile, though not yet common during the era of the suffragettes, gave some women even more mobility.

Once the vote was won in 1920, some young women, known 'round the world as flappers, used their freedom in ways that the suffragettes may not have intended. Though all were not so extreme, many of the characteristics that defined suffragettes and flappers in the public eye made them appear to be constantly in opposition—the staid old suffragettes versus the daring and fresh flappers. Many suffragettes were opposed to alcohol and were influential in the American prohibition of the 1920s; many flappers loved to drink. Suffragettes wanted women to have equal rights to work where men worked; flappers wanted to wear wild clothes, smoke, and make out with men in cars. Suffragettes wanted women to become more involved in government and legislation; flappers just wanted to have fun. As so often happens, not all women see the benefits of feminism in the same way. Whether or not they were activists, however, flappers changed the way the world saw women, and were emulated all over the world—particularly their fashion.

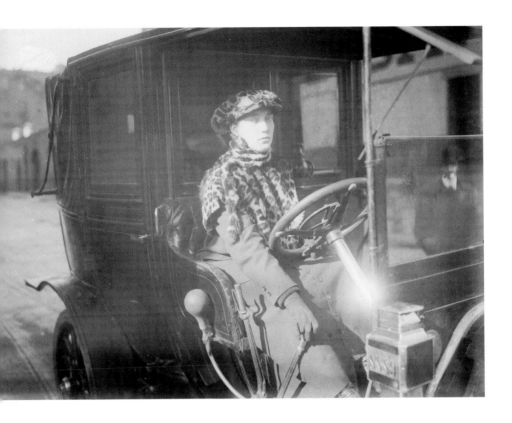

These young women wore clothing with lighter fabrics, less structure, fewer undergarments, and shorter skirts—the least any women in the Western world had worn in public in hundreds of years. And then they bundled on huge, heavy coats.

Coats grew bulkier to provide greater coverage for the lighter clothes, but also to protect people when riding in cold cars. The automobile, which had been in development for more than 150 years, became more practical and affordable for personal use due to Henry Ford's mass-production lines of the Ford Model T, increased availability of gasoline and oil, and the improvement and development of roads and highway systems. However, it took longer for them to have windows and heating.

Wilma K. Russey, in a leopard cape and hat, was the first female cab driver in New York City. In January 1915, the *New York Times* reported, "Woman Taxi Driver Invades Broadway . . . Men Rivals Are Friendly." She is said to have received generous tips.

THE LADIES' HOME JOURNAL

JANUARY
1914

FIFTEEN CENTS

THE
CURTIS PUBLISHING
COMPANY
PHILADELPHIA

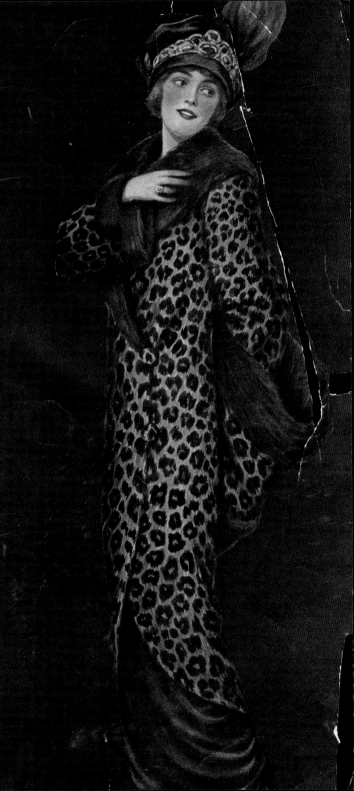

The trim, fitted coats of the Edwardian era had been fine for women who didn't spend much time outside the home. On the rare occasion they took a car ride, they simply covered themselves in furs and blankets and sat in an enclosed carriage alongside the driver. However, for women of the 1920s who wanted to move about more freely and independently and who also wanted to carry their warmth with them wherever they went, fur coats were most efficient (and stylish). There were a few faux furs, including one popularly known as Siberian fur cloth, but faux fur as we know it, made of synthetic fibers, wasn't developed until the 1930s and didn't have the qualities that now make it a good substitute for real fur. Not only did real fur have status in the 1920s, it was also practical for its lightness, comfort, and warmth. Fortunately, fur alternatives would greatly improve, and wearing endangered animals would become illegal.

Clothing became more conducive to movement.

The skimpier the clothes, the heavier the coats became. The early twentieth century saw a boom of popularity for long, thick fur coats. In an illustration by Augusta Drier for the cover of a *Ladies' Home Journal* in 1914, a youthful woman in a long leopard coat trimmed with black fur looks coyly over her shoulder, a jeweled headband and a feather in her velvet cap. Drier was a popular fashion illustrator, so, unlike other illustrated covers from the time that prominently featured made-up clothing, it's likely that this image was based on a real garment. Taking into account the magazine's middle-class readership as well as the garment's apparent drape, this fabric was most likely chenille or velvet rather than genuine leopard fur. Leopard print and other patterns of spotted cats, including Geoffroy's cat, cheetah, lynx, and jaguar, whether in textiles or on real fur, were considered fresh and exciting. These patterns had the elaborate femininity of lace and florals, with a hint of danger; the warm neutral tones of earth with a hint of fire. Its reputation as a pattern for women who weren't afraid to make a statement was beginning to solidify.

Opposite page: Ladies' Home Journal, *1914. This hugely influential and popular magazine, the first to reach one million subscribers, was edited by Pulitzer Prize-winning author Edward Bok from 1889 to 1919.*

Art movements like art deco, Beaux-Arts, and art nouveau incorporated a fantastical sense of history and nature into architecture and interiors, and this sensibility made its way into the world of fashion as well. Art deco adapted the straight lines and lotus motifs of ancient Egypt, Beaux-Arts adapted classical Greek and Roman elements, and art nouveau used flowing lines from nature in an attempt to make man's creations feel more organic. A visual reference to ancient cultures in fashion, real or imagined, continued to be considered a sign of sophistication, even more so if the wearers gave the impression of themselves having visited far-off lands.

Animal prints evoked this sense of a mysterious, larger world. Leopard spots became popular on fabric (rather than fur) toward the end of the 1920s. The motif was not yet the phenomenon it would become, but it appeared on a few couture gowns, as well as on hats and scarves. Highly influential designer and illustrator Erté used leopards and their patterns in many of his fantastic designs.

Women's places inside and outside the home were changing rapidly, fashions were changing with the times, and the world was watching it unfold in new forms of media. This sense of freedom, self-determination, sophistication, and style was made visible to the world in the new and booming business of movies, where the leopard pattern became emblematic of daring and luxury. For the first time, people with no other proximity to the pattern could see it on celebrities, in motion, larger than life.

Opposite page: Joan Crawford prepares to show her claws in 1928.

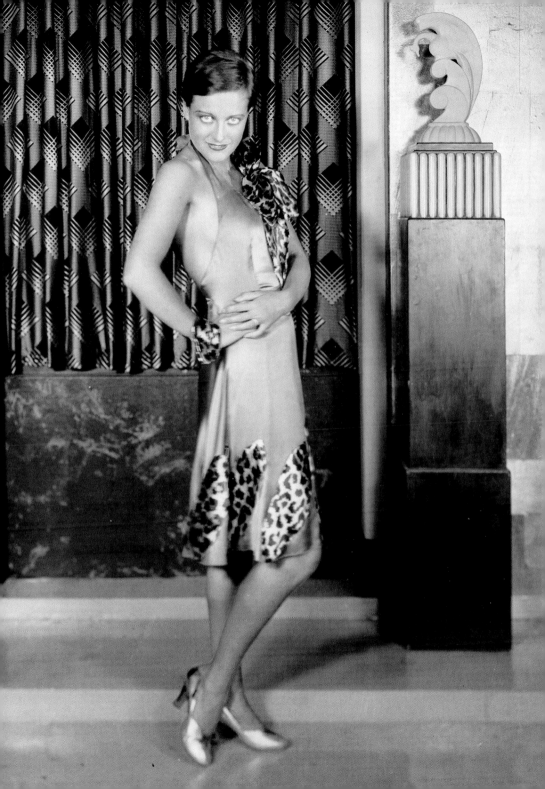

DANGEROUS WOMEN, DANGEROUS PETS

At the turn of the twentieth century, a craze for big cats as pets took hold and lasted for nearly three decades. While a private menagerie had long been a status symbol for nobility, the mastery of a leopard or cheetah made a definite statement about the private citizen who dared to own them. Sometimes the cats seemed more like eccentric accessories than pets, used to express the owner's outrageousness. For instance, Salvador Dalí, who was known for his unusual pets, had a pet ocelot as well as a pet anteater.

Women were often photographed walking their cats on leashes in public. Josephine Baker, one of the most famous and glamorous stars of the 1920s and 1930s, traveled around the world with her pet cheetah, Chiquita, laughing when she nipped at other travelers.

Baker was known both for her outrageous nudity and her devastatingly luxurious clothing, and she and her cat walked together as natural partners in glamour. She went on to host a traveling menagerie of exotic pets that greeted her guests at parties. Though her lavish tastes made her famous, she was also a passionate caretaker and activist. She adopted several orphaned children from around the world, calling them her rainbow tribe, and raised each of them in their respective religions. She served the French intelligence during World War II and was a powerful civil rights activist in the 1950s, refusing to perform in segregated nightclubs and speaking alongside Martin Luther King Jr. at the March on Washington in 1963. She remained in demand as a dancer and singer until she passed away after a triumphant performance in Paris in 1975, at the age of sixty-eight.

A less famous but still notable big-cat owner was Marian Nixon, another star of the 1920s and 1930s. She began her career as a chorus girl on the vaudeville circuit and went on to be a film actress; she was best known for playing the titular role in the 1932 film *Rebecca of Sunnybrook Farm*. Today, she's best known for a 1925 photograph in which she wears a leopard fur coat while walking her pet leopard in broad daylight on Hollywood Boulevard. The leopard seems calm about it, considering his companion is wearing the skin

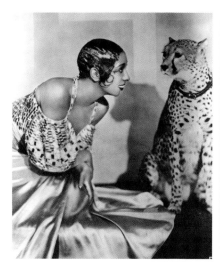

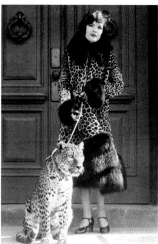

of his kin. A member of Hollywood royalty, leopard by her side or not, Nixon's star on the Hollywood Walk of Fame can be seen at 1724 Vine Street. And here's an interesting tidbit: her grandson, Ted Griffin, was one of the writers for 2001's *Ocean's Eleven*.

These cats were a huge responsibility and expensive to keep, requiring acres to roam and eating up to fifteen pounds of meat at a time. Owning them was not only a sign of eccentric glamour but also of substantial wealth. The cats were genuinely risky as pets, particularly the leopards, who as a species are much more likely to attack large prey than cheetahs. For women experiencing a new level of agency and audacity, these pets represented the power to control a dangerous beast—and perhaps the need for some protection in a world that could still be unsafe for a woman on her own.

Although in the 1920s it was possible to find oneself sitting next to a big cat at an outdoor café in New York or Paris, these days we are unlikely to see a Hollywood star walking a cheetah on a leash for any purpose other than a photo shoot. Keeping large cats as pets gradually became legally restricted to licensed owners, who had to prove their expertise and resources. While the restrictions are more humane for the animals and safer for humans, one can't help but imagine the thrill of a big cat walking into the living room at a glittering Jazz Age party.

Left: Josephine Baker poses with her pet Chiquita.

Right: Marian Nixon takes her big cat for a walk on Hollywood Boulevard.

FEMMES FATALES & FASHION SHOWS

LEOPARD PRINT, WHETHER THRIFT
OR HIGH FASHION, SEEMS TO SIGNIFY, MORE THAN
ANYTHING, A CERTAIN KNOWINGNESS.

—*The New Yorker*

mong all the incredible machines and inventions of the past few centuries, the one that has produced more glamour than any other is the motion-picture camera. But to get to motion pictures, we had to start with stills.

Photography, as we think of it, was introduced in 1839, though the study of light as it affects surfaces—which is what happens when a photograph is taken on analog media, as light literally writes the image upon the film or plate—goes back to antiquity and the camera obscura. The first photos made available to the public were daguerreotypes, named after their developer Louis Daguerre. This process, which involved developing images onto metal, was followed by the invention of photo printing on paper, attributed to William Talbot. Inventors competed aggressively to produce innovations in photography, making it progressively available to amateur photographers; at the same time, high-end inventions helped make elaborate studio shoots and the study of lighting and composition into an art form all its own.

The process of creating motion pictures began several decades later. Today, we're so used to film that it feels as though it's always existed, but the movie theater as we think of it today is barely one hundred years old. Motion-picture cameras were invented in the late 1800s, incorporating innovations by several inventors. The first motion-picture sequences

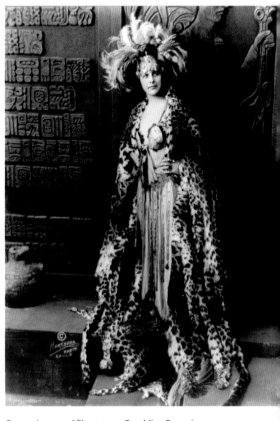

Opera singer and film actress Geraldine Farrar in a spectacular leopard robe, circa 1917. She was a huge star of the era, and her fans were known as "Gerry-flappers."

were filmed by Frenchman Louis Le Prince on cameras he created in England in 1888. The Lumière brothers created cameras that filmed on celluloid, which later became the standard, in 1895.

Thomas Edison was a man of boundless energy and ambition, an incredibly persistent and aggressive inventor, entrepreneur, and salesman. Always eager to put inventions to commercial use, Edison and his team created a more efficient camera in their labs in 1891. He built a tar-paper-covered studio in New Jersey in 1893 and began filming circus and vaudeville performers, including a "muscle dancer"—what we now think of as a belly dancer—and a stripping trapeze artist. When he showed them at the Chicago World's Fair, people were astonished and titillated.

Originally, producers created short films, which, shown in nickelodeons, could be watched by only one person at a time. Later, after the projector was invented and improved upon, larger audiences could view the film shorts as they were projected onto curtains and walls, and the

shorts were openers at vaudeville and other live shows. It didn't take long for the shorts to work their way to feature-length. Movies quickly became America's favorite form of entertainment and rapidly evolved into a worldwide industry.

Movies and their associated glamour were welcome distractions during World War I. Later, during the gaudy Jazz Age of the 1920s and 1930s, cinema continued to be a delightful pastime. Drinking illegal bathtub gin, to get around Prohibition, was another heady pleasure and welcome distraction. And, still later, during the Great Depression, the

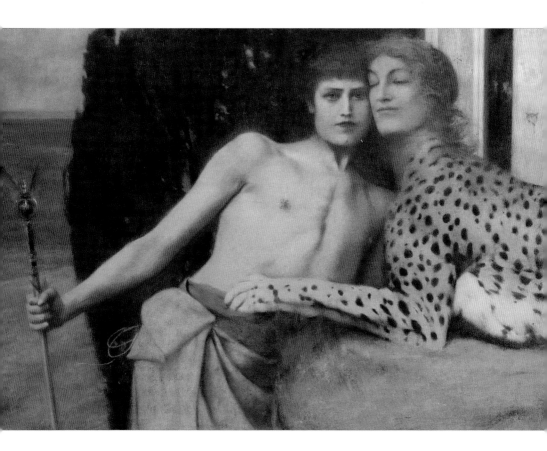

wonders of cinema provided weary, panicked audiences with a much-needed respite.

For the lower and middle classes of the early 1900s, watching short films in nickelodeons and plain theaters had been enough. In order to be attracted to the idea, the upper class, however, demanded the kind of luxurious experience to which they were accustomed in opera and theater houses. Many were also concerned about the concentration of toxins in the film stock used in the arcades (not unlike a modern game arcade) where rows of nickelodeons were staged for individuals to watch.

The Caresses, 1896. In this painting by Fernand Khnopff, a femme fatale in the form of a cheetah-sphinx appears to entice an innocent man.

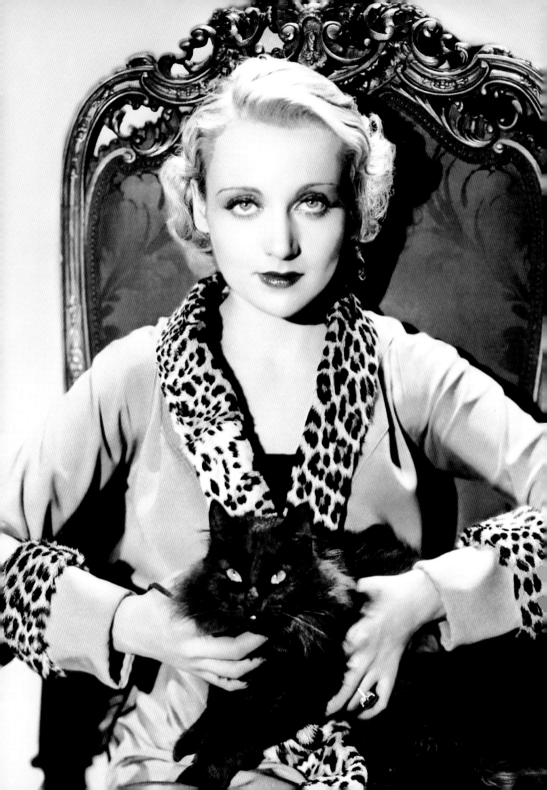

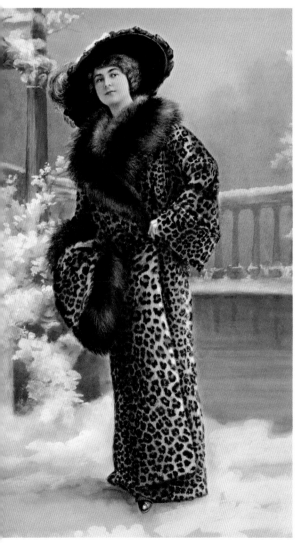

Opposite page: Carole Lombard, the highest-paid film star of the 1930s, was originally known for her comedic gifts as a Mack Sennett Bathing Beauty. Her style influenced legions of fans, helping to make leopard print velvet popular on jacket fronts and dressing gowns.

Left: French opera singer Nelly Martyl, 1904

Right: Lee Meriwether gets catty in the 1966 Batman movie based on the campy television show.

Régina Badet, shown here in 1905, was a Parisian dancer and actress who caused a stir with her level of undress. Leopard was often used in early films to evoke the sophisticated world traveler, the untameable woman, or the aesthetic of orientalism.

Opulent movie palaces were constructed seemingly overnight in prestigious locations, costing up to one million dollars each, beginning in the 1910s. Hundreds opened during the 1920s, featuring gilded walls, velvet seats, and ceilings painted to resemble skies. While originally created to court wealthy customers, it didn't take long for prices to be lowered in an effort to appeal to the middle class and to help maintain profitability. Electrical air-conditioning was invented in the early twentieth century, based on ancient Egyptian and Roman processes of cooling air and walls with water. Once it was added to movie theaters, it became a staple of advertising and made going to the movies even more irresistible in an era when few private homes had AC: "Come inside and cool off!"

As movie stars became the most famous people in the world, everyone wanted to emulate their style both on- and offscreen. The pamphlets and fashion plates that helped dictate popular sartorial trends of the previous centuries were easily eclipsed by the movies along with their

related publicity. Stars were photographed and featured in magazines with large readerships. Never before had audiences had such access to study—and emulate—celebrity style.

Female iconography previously seen in art and illustration was brought to life onscreen. The femme fatale, an irresistible seductress with a hidden agenda, was one of the greatest. She was portrayed as an evolution of the evil goddesses of ancient worlds, often in the form of a vamp, who could suck the virtue and the life out of good men. She often appeared, like gods and goddesses of Greece and India, seated on or draped in spotted furs, predatory and remorseless. She was part of a wave of orientalism in film, which created the atmosphere of an imaginary Far East that overexoticized and exploited Eastern and Middle Eastern culture to create a mysterious effect. The most famous vamp of them all, actress Theda Bara, starred in dozens of features during the silent film era, and retired in 1926 before ever making a talkie. Never one to shy away from being portrayed as the bad girl, she once said, "To be good is to be forgotten. I'm going to be so bad I'll always be remembered."

Most actresses who played the part of the bad woman seemed to get real pleasure out of the role. Pola Negri, another femme fatale, kept a cheetah as a pet, and said that all the rumors about her exotic past were inventions of publicity. Louise Glaum played the starring role in *The Leopard Woman*, a silent film released in 1920. Billed as a "fascinating enchantress," she wore a thick leopard fur drape and a hat in the shape of a cat's head; she said that the first thing she ever knew about being a vamp was seeing herself called one in the papers.

Vamps stole men's souls and gained control of their money—and to be fair, at the time there were few ways, short of being a famous actress, that a woman could get her own money. Men were simultaneously repelled and thrilled by vamps, and women, perhaps, fantasized about being them.

Music was originally played live in theaters, usually on a piano, to accompany the movie. The earliest films with sound were produced in 1900, and occasionally exhibited, but the technology wasn't suited for commercial films until decades later. As soon as sound was ready to

A bespoke garment inspired by Marilyn Monroe's 1953 fur cape, created in 2017 in vegan fur by Iconic Dresses UK.

present human voices in the mid- to late-1920s, musical performances were incorporated. The talkie caught on around the world, and its feasibility was the catalyst for film industries in other countries to develop motion pictures for their own market, particularly India, which was producing spectacular visual and narrative films from the start, featuring their own style of music and dance.

American musicals offered big production numbers and created their own star system. A new kind of vamp, much less threatening and more genial, was created in the musicals of the late 1920s and early 1930s with a series of films about a dance troupe called the Gold Diggers. While only bits and pieces of some of these films remain, they are partly responsible for the idea of the showgirl and actress as a glamorous character in her own right, not just for portraying an otherworldly character. They managed to combine the freshness of America's sweetheart of silent film, actress Mary Pickford, with an openly ambitious nature.

Gold Diggers liked to dress up, and they liked to wear fur. It was just past the era of the giant fur coat, and the style of the 1930s was closer to the body; those trimmed with leopard, real or faux, were particularly chic, though the look was less feral than in portrayals of the vamp. Vamps often wore coats with matching collars, cuffs, hats, and muffs. While the full fur coat still had its adherents, particularly in colder climates, the trimmed coat felt more modern.

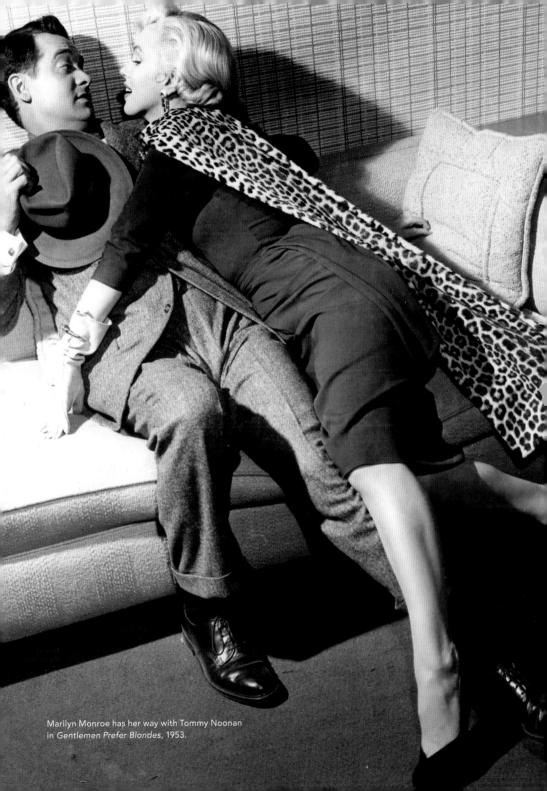

Marilyn Monroe has her way with Tommy Noonan in *Gentlemen Prefer Blondes*, 1953.

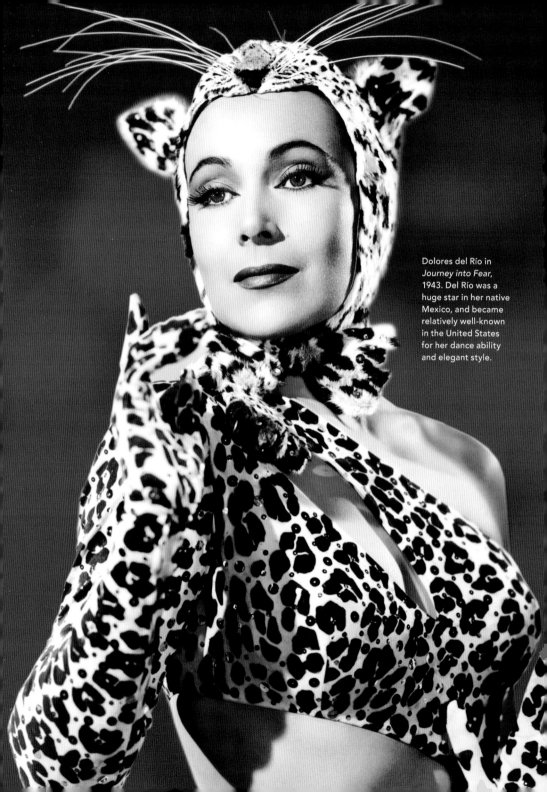

Dolores del Río in *Journey into Fear*, 1943. Del Río was a huge star in her native Mexico, and became relatively well-known in the United States for her dance ability and elegant style.

Fashion designer Elsa Schiaparelli, known for her intellectual and often surrealistic style (she collaborated with Salvador Dalí, who, as previously noted, kept an ocelot as a pet), incorporated a cheetah face into one of her most famous hats in 1937, a hat which was reproduced in faux fur for Julie Dreyfus's character Francesca in Quentin Tarantino's 2009 film *Inglourious Basterds.*

The high glamour of the fur—leopard, jaguar, ocelot—was the primary presence of the pattern at the time. Although much of it was faux fur or velvet, modern viewers may find it disturbing to see so much real fur when they recognize it. While wearing the pelt of such a precious and rare animal is rightfully shocking to most of us today, fur played a different role at the time. Anti-fur fashion expert and on-air mentor of the cult-favorite television show *Project Runway* Tim Gunn notes that in the early twentieth century there weren't as many viable alternatives, and even though cars had gotten substantially less drafty than in the 1910s and both cars and houses had interior heating, fur was still a matter of practicality as well as of fashion. This situation improved as the century progressed.

Actress Julie Dreyfus in Quentin Tarantino's *Inglourious Basterds*. Her hat is reminiscent of one created by influential avant-garde designer Elsa Schiaparelli.

Leopard print was very slowly sneaking its way into vogue in Western fashion throughout the 1930s, but it was usually treated as a sporty print, appearing on headscarves and in soft summer dresses, often in pastel colors. It was a daytime fixture, outdoorsy, practically a floral. Fashion designer Christian Dior understood the pattern in his uniquely insightful way, and he was about to show everyone what leopard print was really about.

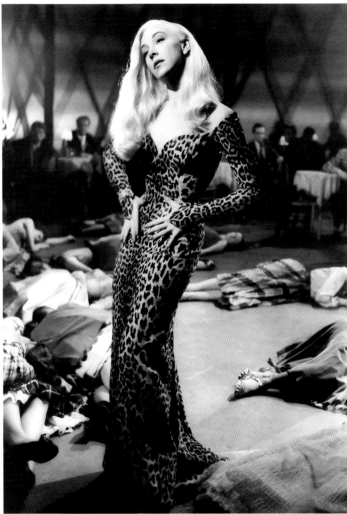

From left to right: Legendary bombshell Carmen Miranda poses in leopard on leopard—more of a friendly femme than a fatale; Belita in *Invitation to the Dance*, 1956, is a prime example of the use of cat-patterned clothing to evoke a dangerous female. She appears in the film in a single scene, walking into a crowded room and making all the women faint. Her character's name is listed in the credits only as "Femme Fatale."

FASHION SHOWS & FILM

The movies have always influenced fashion and what people wanted to wear, and fashion designers have always worked closely with filmmakers. Early films began incorporating fashion shows into their plotlines, and department stores would promote films along with the designers' names in dedicated spaces on their premises, where women could go and order the fashions they'd seen on the big screen. Almost anyone could see fashion in films while high-end fashion shows had been available only to a few select viewers.

The fashion show as we think of it had several early incarnations. Salons in Paris had fashion parades in-house in the 1800s, and the format caught on everywhere, from Weimar Berlin to Shanghai. Department stores sometimes staged huge themed fashion events, which attracted hundreds of attendees, who might be interested in the show even if they couldn't afford the clothing. Later, fashion shows consisted of models walking among shoppers. Their primary purpose was to appeal directly to the likely wearers—less like today, when designers' shows are primarily for fashion press and store buyers. Fashion shows on film made them accessible to everyone.

One of the most remarkable fashion shows on film is in George Cukor's 1939 movie *The Women*, with clothing by Gilbert Adrian. The film is black-and-white, but as the fashion show begins, the screen bursts into color. The fashion show opens with a few sporty tennis outfits and then becomes a display of fantastic themed creations, some of which would do any surrealist proud. Over Adrian's career he would show a particular adeptness with animal print, influencing film viewers and fashionistas everywhere.

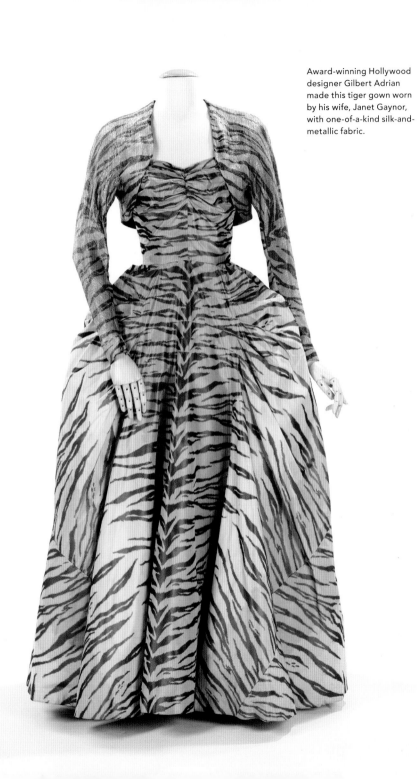

Award-winning Hollywood designer Gilbert Adrian made this tiger gown worn by his wife, Janet Gaynor, with one-of-a-kind silk-and-metallic fabric.

HAUTE CAT-OURE

IF YOU ARE FAIR AND SWEET,
DON'T WEAR [LEOPARD PRINT].

—Christian Dior

Christian Dior's introduction of leopard print into his 1947 debut haute couture collection made the pattern a fashion staple. He made leopard print more desirable than anyone short of the leopard herself.

Dior knew from an early age that all his good fortune would come from the women in his life. When he was thirteen, a fortune-teller told him, "Women are lucky for you, and through them you will achieve success." Dior would go on to design some of the most beautiful and influential women's clothing of the twentieth century. He surrounded himself with strong and independent women, and relied on their expertise and authority within his atelier as muses, creatives, and businesspeople. He also continued to consult with soothsayers, and relied heavily upon the personal guidance of fortune-teller Madame Delahaye. Her advice seems to have worked: sixty years after his death, his fashion house remains significant and prosperous.

Dior was born January 1905, in Granville, France, a city famous for its carnival festival that featured elaborate costumes and a fancy-dress parade in which he loved to participate. His wealthy parents moved Dior, along with his siblings, Raymond, Jacqueline, Bernard, and Catherine, to Paris in 1911. They lived in the trendy Sixteenth Arrondissement during the belle epoque, where he was further exposed to culture, beauty, and luxury. When war broke out in 1914, he and his siblings were

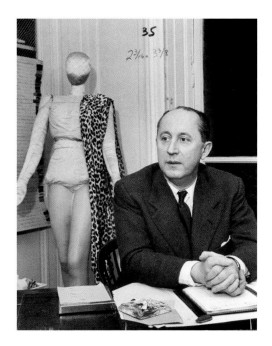

sheltered from its harsh realities. Of relevance to his later career choices, Dior describes a memory of the bourgeoisie women around him being horrified by the changes in fashion the war demanded but ordering those despised fashions anyway.

In contrast to the beauty and glamour of Paris, his father's wealth was created in fertilizer factories, where Dior was revolted by the shipments of guano. He developed an antipathy to both machinery and offices and became determined never to work in such dull environments. While his family's original goal for him was to become a diplomat, his eye was always on the arts, and his father supported him when he chose to run an art gallery in his twenties. The gallery eventually closed, but Dior remained interested in the arts and became involved in fashion design. In 1937, he was employed by Robert Piguet, who trained him and had him design three collections. Dior worked with some of the best names in fashion design in the house of Piguet, including Pierre Balmain. He was devoted to fashion and left the industry only because he was called to military service. After completing his military obligations in 1942, he returned to Paris and to fashion, more determined than ever. He was thrilled to join the fashion house of Lucien Lelong, where he worked throughout World War II as a designer.

France and Germany had a centuries-long difficult relationship prior to the war. Some of these conflicts seem trivial compared to the war, but they cut deep to the nationalistic pride of each country. Germans would often claim that French fashion was frivolous and decadent and was a distraction to, and had a detrimental influence on, their people, while the French would make fun of Germans' attempts to be chic. Germany's fling with chic during the Weimar period and its popularization in film had its most powerful effect between the world wars, but France remained at the center of the Western world in terms of fashion qua fashion.

He surrounded himself with strong and independent WOMEN.

During their occupation of Paris, the Nazis limited the Parisians' personal freedoms, access to food and supplies, and maintained an atmosphere of intimidation. The city's famous lights were lowered. The city's usual sounds—music, street traffic, and people talking and laughing—were replaced with sirens, airplanes, and the orders of Nazi officers. While we now know that this occupation ended with the liberation of the French, at the time it seemed the beauty and liveliness of the city were forever dimmed.

Many of the Allied countries, such as France and Britain, rationed all their resources, including fabric. As a result, new fashions were subdued; women working in factories required fewer party dresses. Though they could usually find a pretty frock to wear when soldiers came through town, no one expected anything new.

The Nazis, requiring their self-proclaimed superiority be recognized and celebrated in all possible arenas, did not forget the mockery of the French when they occupied Paris. They were eager to have at their service the finest fashion houses still remaining in France, and would have all the fashion for themselves. They effectively cut off all of Paris fashion from the rest of the world, isolating the great houses from producing for anyone else, and cutting off the world from the influence of French ateliers. Dior, along with all the French designers who had not

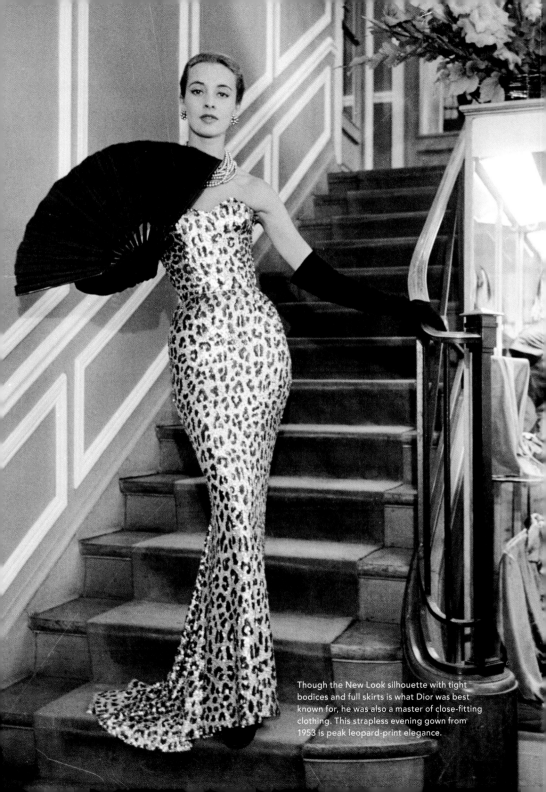

Though the New Look silhouette with tight bodices and full skirts is what Dior was best known for, he was also a master of close-fitting clothing. This strapless evening gown from 1953 is peak leopard-print elegance.

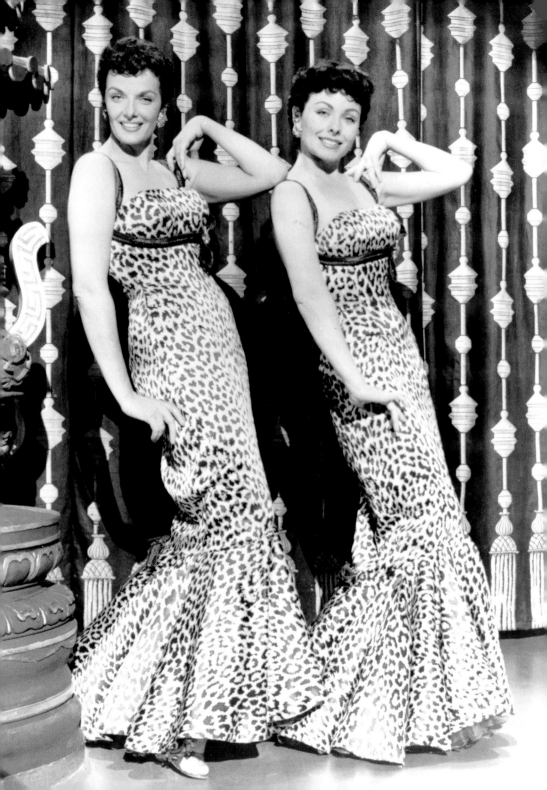

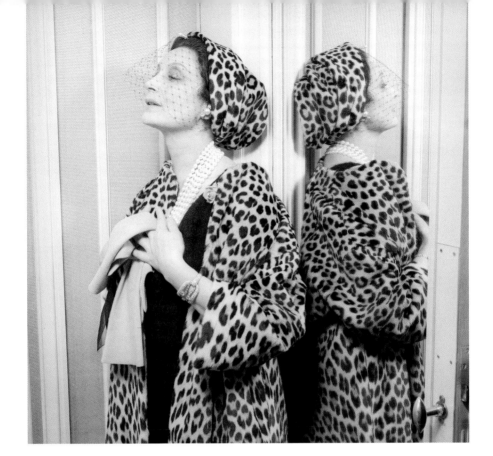

left the city before the occupation prevented them from doing so, was required to make gowns for the wives of German Nazis, who dressed to the hilt in clothing that, when not stolen from Jews on their way to concentration camps or sewn by captives of those concentration camps, was the latest (and only) French fashion of the day.

Because so many of the men of Paris were at war, in concentration camps, or in hiding, the Resistance was fueled by the vigor and efforts of women and girls. They were a force to be reckoned with, and the glamour some of them maintained was part of their rebellion. Rather than allow themselves to be depicted as servile, shabby, or defeated, many young women in the French Resistance decided to portray themselves as well-groomed and fabulous despite Nazi restrictions on their couture. This

Opposite page: Jeanne Crain and Jane Russell head to Paris in *Gentlemen Marry Brunettes*.

Above: Mitzah Bricard was one of Dior's principal muses, known for wearing leopard almost daily. The Dior brand still references her name in their cosmetics and fashion lines.

took a distinctly different form than that of the luxury-obsessed Nazi wives. In Poland, where circumstances were dire, teenage Jewish Partisan hero Faye Schulman recovered a leopard coat while raiding her Nazi occupied home town, then wore it while fighting them, its pattern helping to conceal her during life-and-death maneuvers in the snowy woods.

A famous photograph from 1944 shows a trio of armed French partisan fighters concealing themselves against a wall preparing for the liberation of Paris. One of them is an eighteen-year-old woman, Simone Segouin, in a beret, stylish shorts, and boots, with a fashionable hairdo somewhat mussed, possibly wearing lipstick, holding an MP40 submachine gun. Her face looks serious, as does her gun, but she also looks poised, attractive, and chic. It's a jarring combination, to be sure, but a memorable one. If fashion is part of the pride of Paris, she is representing.

Dior's sister Catherine was a member of the French Resistance, and collaborated with other members out of an apartment on the Rue Royale. She was found out, captured by the Gestapo, and deported to a women's concentration camp. Dior tried to help her but had no news of her for a year, other than from a psychic who continued to assure him that she would be all right. Paris was liberated in August 1944. Germany surrendered in May 1945. When Dior picked up his sister after her release from the camp, she was malnourished and ill but otherwise safe. After the war, Dior continued to work as a designer whose creations celebrated his love of and appreciation for women.

While Dior prepared for his first post-war collection, his first-ever solo collection, he also worked on his first perfume, but despaired of a name. One day, Catherine breezed into his studio and it became clear that she, representing the courage and spirit of post-war women, must be the perfume's namesake, and he called it Miss Dior. The perfume was sprayed in the air during the presentation of his premiere collection in 1947, and his New Look fashions, with tapered waists and full skirts that showed that the fabric-rationing days of the war were clearly over, instantly became one of the most famous silhouettes in fashion history, and Dior became a fashion celebrity. The early ads for Miss Dior showed an elegant woman's hand resting on top of a leopard's paw.

Opposite page: In the 1950 film *Sunset Boulevard*, Gloria Swanson plays Norma Desmond, a former celebrity lost in her delusion of returning to her youthful stardom. The costumes were designed by Edith Head, with an intentional reference to Dior. Swanson is seen here as Desmond trying to recapture her youth in the leopard she associates with glamorous success.

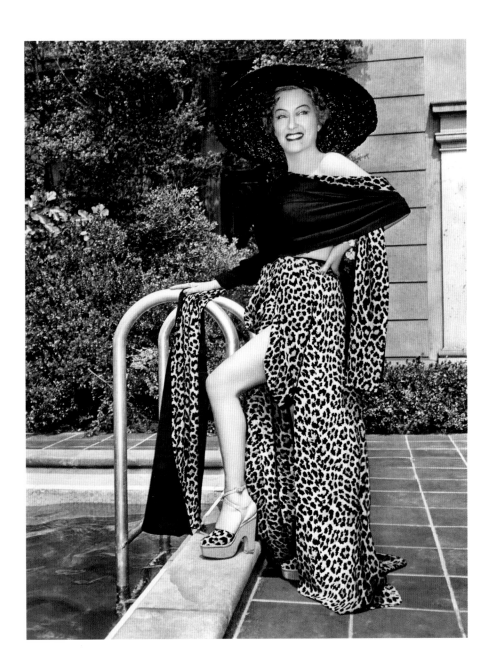

Leopard became a significant motif in Dior's atelier. One of the most influential women working with him was Mitzah Bricard, who wore leopard print almost every day, whether on her hat and coat, or on a silk scarf tied around her wrist. She was a former courtesan who claimed she dropped out of the profession because the newer women in her field weren't charging enough, thereby degrading the mistress vocation. She was a hat and accessories designer upon whom Dior relied daily for inspiration, insight, and creative direction. As a muse, she gave Dior inspiration for a creation that even today seems contemporary, if not as well-remembered by many as the New Look.

Leopard found its highest expression to date in a body-fitted sheath Dior presented in his first show in 1947. Where the full skirt of Dior's New Look obscured the hips, this dress displayed the architecture of the female body. Named "Jungle," it clearly referred to the concrete rather than the tropical kind, giving the modern woman the ability to move on city sidewalks with the self-assurance of a great cat. When the pattern was used in an evening gown and photographed for publicity, the setting and the model's pose reflected the combination of all Dior wished to evoke: the tall streamlined walls of a modern mansion, the staircase columns echoing antiquity, and a simple, perfect updo that reflected both the empire era of France and the formal restraint of modern hairstyles. The collection also deliberately evoked Africa, from which soldiers had fought as Allies—some voluntarily, others not—against the Axis. The dresses presented worldly, knowing restraint combined with the strength, adaptability, freedom, and sensuality associated with leopards. The mood of the fashions seemed to imply a new harmony in the world, one where the women held sway. The print on fabric finally became as haute as the fur, evocative of controlled ferocity that connected cool poise to fierce daring. Dior minced no words on his opinion of the power of leopard print, saying, "If you are fair and sweet, don't wear it." It immediately became the print of the world's most sophisticated women. French fashion was reestablished as one of the catalysts of culture, self-actualization, and success, and leopard print had made its mark.

Opposite page: Cyd Charisse was one of the most celebrated and technically proficient on-film dancers of all time, with the best tendu in the biz. A frequent player of seductresses and femme fatales, Charisse wore this dress for a dance scene in 1958's *Party Girl.*

BOUDOIRS, BOMBSHELLS & BIKINIS

BUT THAT'S THE THING—LEOPARD
IS SEASONLESS. AND WHILE RIGHT NOW IT'S HOTTER
THAN EVER, IT'S ALWAYS BEEN JUST . . . COOL.
ESPECIALLY FOR FLIRTING WITH POOL BOYS AND
DRINKING IN THE DAY.

—*Harper's Bazaar*

I n the 1950s, leopard print was the pattern women liked to wear closest to their skins. They were photographed more than ever, and in less clothing than ever. The bombshell in the leopard-print swimsuit and the boudoir maven in leopard-print lingerie became a staple of modern female iconography.

Pinups, images of women produced for the purpose of being admired from afar, have existed for as long as there have been walls to put them on. Artists have long painted or otherwise made visual presentations of desirable people, and the introduction of photography made it easier than ever to give viewers the feeling that they were really in the room with the subject of their affections. Most photographic pinups looked directly into the viewers' eyes—"I'm for you," they seem to say. During World War II, posing for pinups was practically a patriotic duty. Women who weren't in show business sent pictures of themselves to their sweethearts in the fields to hold as mementoes not only of their affection, but also of what they were fighting for: the devoted girl back home. Movie stars took it further, posing in patriotic settings and costumes as well as in skimpy clothing, usually with a fresh face and a smile that gave the impression that everything back home was swell. These images were tacked up on the walls of barracks and tents. Not all waited at home; actress and singer Ida Lupino not only appeared on their walls but also served as a lieutenant in

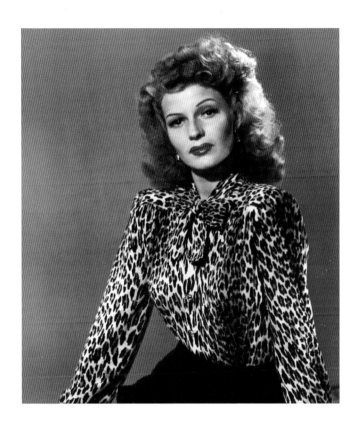

One of the most popular pinups of all time, Rita Hayworth is rumored to have been stenciled on the side of an actual bomb. Her style was always sophisticated and enticing.

the Women's Ambulance and Defense Corps of America. After the war, she became one of the first women within the Hollywood system to work as a producer and director. The pinup, a friendly and accessible reminder that women were supporting their fighting men so far from safety and comfort, was a booster to morale. When women later became more directly active in the military, these pinups came to be seen as minimizing and objectifying, but during World War II it was considered an honor and a privilege to be a pinup.

At about the same time, the word "bombshell" emerged in popular slang. The association of glamorous women with bombshells refers not

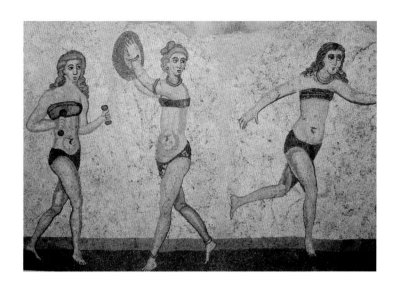

From top to bottom: This mosaic of female athletes or dancers playing in bikini-like garments is from the Villa Romana del Casale in Italy. Though the archeological site dates from about 1,700 years ago, this mosaic was only discovered more recently, and after the modern bikini was first presented to the public in 1946; Gibson Girls, the very image of the modern woman in the late nineteenth century, frolic in the surf in their bathing costumes.

just to their metaphorically explosive effect on the viewer's libido but to actual war hardware as well. Fighter planes and bombers often featured personalized artwork on their sides, providing inspiration and the hope of luck. Some chose to make the planes appear fiercer with designs featuring sharks and tigers or images of other war heroes. Some chose to make light of fear and danger by using cartoon characters full of bravado, such as Mickey Mouse or Bugs Bunny. Many favored images of beautiful women. These literal bombshell women were purported to be integrated into the weapons themselves: Rita Hayworth, for example, was depicted as the eponymous glove-peeling songbird from the 1946 film *Gilda* on the side of the fourth atom bomb tested on Bikini Atoll.

Leopard print was the pattern women liked to wear closest to their skins.

The two-piece swimsuit, an innovation in beach fashion named after Bikini Atoll, was soon to become the most popular choice of clothing for pinups. At the time, the atom bomb was a celebrity much admired, and to be compared to it was a serious accolade. Furthermore, the name was an indirect reference to the atom itself. If an atom was the smallest unit of a chemical element, then the bikini was the smallest garment that could be worn and still be considered a swimsuit. Moreover, it was a one-piece split into two, like an atom being split to induce the explosions that bloomed across American television sets and magazines. The addition of the wild element of leopard print to the outrageous two-piece suit made a bold and playful statement about the woman who chose to wear it.

It wasn't the first time swimwear had been considered outrageous, or even that women in public had worn anything so small. Roman sportswomen had worn two-piece costumes, after all.

Swimwear prior to the twentieth century was a sensitive matter, however. In the Middle Ages, people generally swam bare or in their

Ava Gardner was a woman of talent, wit, and outstanding glamour. She was a popular pinup in the 1940s and 1950s before her film career took flight.

underwear, and because it required that people be so close to naked, swimming was looked at askance by moralists of the time. However, it was hard to resist the call of the beach. Women looking to get some sun and swim in the late 1800s wore modest and bulky suits only somewhat less heavy than their clothing, which prohibited them from enjoying any level of ease or speed. A five-pound swimming costume could easily become twenty pounds of clothing when wet, and could be quite danger-ous if one actually tried to swim.

In the early twentieth century, leisure sports became symbolic of a new aesthetic for glamour and luxury, and of a new moral imperative toward health. Getting exer-cise outdoors became quite the thing, and the human body was increasingly recognized not as a site of poten-tial immorality to be constantly monitored for unhealthy desire, but as an engine of natural drives. Women needed to be more mobile in their clothing to ride bicycles and to play tennis, and they certainly needed to be more mobile to swim. The pursuit of health led to a new appreciation for sports and, as in Roman times when athletes wore skimpy costumes or nothing at all, modern athletes began to wear much less. Swimwear became more appropriate to actually swim in, and women took full advantage.

A 1970s bikini shows the hip-hugging waistline popular during that era. While the side straps have moved above and below the hipbone over the decades, navel baring has remained the norm.

When the bikini—created by French automobile engineer Louis Réard—made its first appearance in mod-ern times, it was considered so scandalous that no fashion models would wear it for its debut public event in 1946. Réard instead hired Micheline Bernardini, a nude dancer from the Casino de Paris, to wear his creation. While not the first two-piece swimsuit, Réard's was the first to show the wearer's belly button. Burlesque dancers often wore smaller costumes onstage, but not on public theater marquees, where many county sheriffs consid-ered it indecent if the dancers' navels were exposed in advertising images that could be viewed from the street. Throughout the 1960s and 1970s, the belly button remained a point of contention regarding decency on

Bettie Page posed regularly for gentlemen's camera clubs and fetish photographer Irving Klaw, and was a favorite of superphotographer Bunny Yeager. She was known for her love of leopard print and continues to influence pinups everywhere. This image, depicting Bettie as a jaguar, is from celebrated modern pinup artist Olivia DeBernardis.

television, too: Barbara Eden was restricted from showing it, despite her two-piece genie costume on the fantasy show *I Dream of Jeannie*, and it was still a matter of comment when Britney Spears bared hers in the late 1990s. It's no surprise that the belly-baring bikini was controversial in the 1940s.

Over the next decade, the bikini inched its way into the mainstream, while not always as skimpy as Réard's 1946 string bikini. It infiltrated popular culture in the hit song "Itsy Bitsy Teeny Weeny Yellow Polka Dot Bikini" and the 1965 movie *How to Stuff a Wild Bikini*. Throughout the 1950s and 1960s, one movie star after another appeared in the two-piece leopard-print bikini, usually captioned with a reference to wildness or

Savvy Jayne Mansfield gave the impression of savoring her flashy sex-bomb image. Known for wearing low-cut gowns and participating in publicity stunts in bikinis, she was a devoted wearer of leopard- and ocelot-patterned swimsuits, coats, pants, and more.

the jungle. Pinup star Bettie Page made her own leopard-print bikinis and robes. Cordie King, one of Chicago's most famous black models, posed in a leopard-print bikini for a centerfold in the November 1955 issue of *Hue* magazine as the "Lady of the Lake." Flamboyant blond movie star Jayne Mansfield made the leopard-print bikini her trademark, posing with her strongman husband, Mickey Hargitay, in matching leopard trunks.

While the bikini ruled in the sunshine, leopard-print lingerie took over the boudoir.

Lingerie was rarely printed before the twentieth century, as most underwear was purely functional, a layer to provide protection, comfort, and form. Any other kind of underwear was the purest luxury. Most was plain, made of linen or cotton batiste, though the indulgent would wear silk. Decorations, when they occurred, took the form of elaborate seaming, embroidery, or lace. Prints first became popular on lingerie in Western fashion when they began to appear on pajamas, robes, and loungewear in the 1900s to 1920s. Lingerie for fashion became more popular as the previously "unmentionable" began to appear in film in the 1930s and 1940s. Printed lingerie became more popular after World War II, while the process of printing and producing fabric became even more mechanized and affordable, and post-war exuberance and freedom from fabric rationing encouraged the acquisition of more frivolous garments. Once prints began to appear on lingerie, leopard print was inevitable. It is only surprising that it took so long to become a wardrobe staple.

Vanity Fair changed everything when the company introduced its signature leopard print on bras, slips, and other intimate items beginning in 1953—a bold move for a company of their long-standing reputation. The venerable manufacturer started as a glove and mitten company in 1899 but, after financial trouble, reorganized and began producing silk underwear as well. Eventually they eliminated glove production and produced lingerie exclusively, becoming one of the first to employ the new artificial fiber, rayon, in the 1920s. When binding elastic was introduced in the 1930s, they began to make underwear that fit close to the skin rather than the more open style of tap pants and chemises, producing bras and panties in the styles we recognize today as modern underwear.

During World War II, when they and other lingerie companies produced parachutes for the military, they began using nylon, which became the fabric they used exclusively. The fabulous leopard nylon fabric they produced in the 1950s is still a favorite of collectors today.

Vanity Fair advertised in high-end magazines, using images of lingerie-clad women discreetly turning their heads or shading their eyes. At the same time, the Maidenform lingerie company was using flamboyant ads of women in bras turning up in public places with their slogan, "I dreamed I went to the [circus, masquerade, boxing ring, etc.] in my Maidenform bra," making their ads more playful, and more fantastic, and therefore more acceptable to the public eye, and unintentionally providing a perfect foil for the seductive style of Vanity Fair's campaigns. Vanity Fair's leopard-print ads, with their signature pose of discretion, made their lingerie feel like a very private affair, evoking a potent, nocturnal sensuality. The leopard print was made to feel exclusive, something a woman chose for herself, and to see her in it was a special privilege accorded only to her lovers, and the voyeuristic eye observing the advertisement. Naturally, it was a sensation.

Twenty-first-century vintage clothing dealer Amanda Suter models a 1960s Vanity Fair palazzo lounger. Vanity Fair produced loungewear such as robes, pajamas, and jumpsuits as well as bras, panties, and slips in their popular leopard-print nylon.

Other companies picked up the pattern immediately, most notably Frederick's of Hollywood. Frederick's opened in 1947 with an overt bombshell and pinup aesthetic. In the introduction to a book about his catalog company, founder Frederick Mellinger said he started the company with memories of girls whose images turned him on when he was in the U.S. Army: "I wanted to help make *any* woman her most feminine,

Left: This 1982
cabinet card
depicts undefeated
champion sword
fighter Jaguarina.
She was promoted
as being so skilled
that many champion
swordsmen feared
fighting her at all.

Right: Angie Pontani,
neo-burlesque
pioneer, looking
sharp in 2014 in a
vintage-inspired
lingerie set.

alluring, sexy self. . . . I have always believed that a woman should dress to please the *man* in her life." This heterosexist stance resulted in some of the most entertaining, outrageous, perhaps unintentionally campy catalogs in clothing history, featuring padding for all the body parts, along with discreet packaging that helped him serve an up-and-coming male-to-female drag community. Some of the earliest catalogs featured underwear, dresses, and faux fur coats in "daring leopard print" designed to drive men wild (whether they wanted to see women in it or be the ones wearing it). Women who were not fair and sweet, of course, loved the print.

The sexier the bikinis and lingerie became, the more luxurious the implication of the authentic fur became. The 1950s and 1960s were the apex of the American dream, a time when every woman was told that if she bought the right products, clothes, and cosmetics, she had a chance to be the Perfect Wife. What could go wrong?

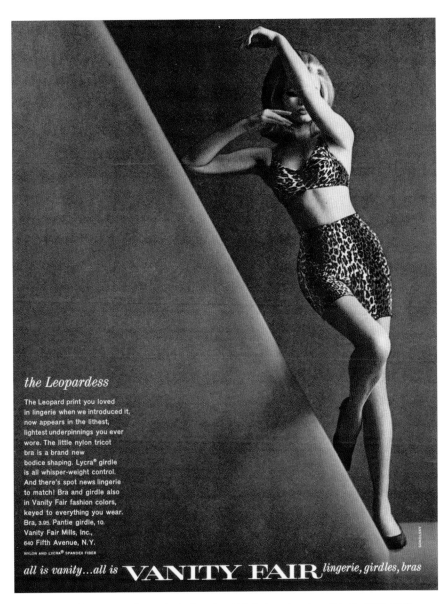

A 1953 ad for Vanity Fair leopard-print lingerie, which the brand produced into the 1970s. With its variegated background of ivory and dark gold, this print on fine tricot is a collector's item.

SKINTIGHT

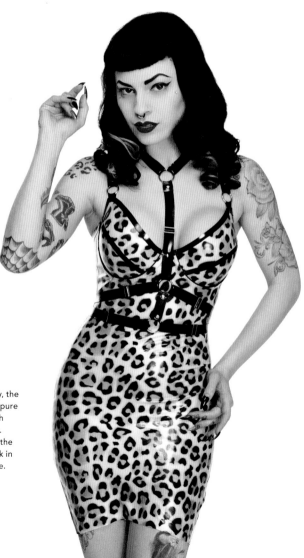

In the late twentieth century, the skintight-est clothing of all, pure latex, made its way into both high and alternative fashion. This dress from 2017 shows the influences of pinup and punk in an elegantly subversive style.

Skintight clothing and underwear is a relatively new phenomenon. The images we see of tight-fitting clothing prior to the twentieth century are often painted without showing the wrinkles and gaps in fabric that may have been present in the same way that many photographers today use photo-editing software to remove. The textiles and garments that have been preserved often prove that the smooth, tight fit some of the paintings and illustrations show was unlikely to compare to what clothing shoppers today expect from body-con fashions that benefit from modern elastic fibers.

The drapes of ancient cultures were shaped on the body by wrapping fabric, usually held in place with belts and brooches. When garment makers began to use seams, since there were no machines they were all hand-stitched, and without patterns for sizing, the seams were all straight. Garments weren't even laced, as corsets are, until about the twelfth century, when they would begin to be laced through hand-sewn holes, in order to bring the clothing closer to the body.

Curved seams and close fits were popular in the eighteenth and nineteenth centuries, and so was lacing. Hooks and eyes for clothing and busks on corsets became popular in the nineteenth century. With the exception of a rage for light flowing gowns in Napoleon's court, fashions were elaborately fitted to the body.

Through the nineteenth and twentieth centuries, options for fitting became more accessible. The sewing pattern was invented in 1863 by Ebenezer and Ellen Butterick; the tape measure was invented in 1868 by Alvin J. Fellows. These inventions made it possible to fit clothing to each specific body with precise measurements and for curved seams and darts to accommodate the measurements.

However, even with knitted fabrics taken into consideration, clothing didn't have a chance to be skintight until the invention of elastic yarns. Elastic fastenings existed as early as 1820, and the rubber band in 1845. Wide bands of elastic could fit waistbands directly to the waist, and narrow bands could fit lingerie. Most of the lingerie through the 1970s had as much fit as knits can allow, but that's nothing compared to what spandex can do.

The first use of spandex/Lycra was in swimwear and lingerie in the 1980s. Made of fabrics knit with neoprene threads, it enabled a four-way stretch that fit fabric directly to the skin. Its use in leotards and activewear led to the (some claim unfortunate) wearing of leotards and leggings in public. For the first time, the average consumer could buy a catsuit that made her look like a superhero—or a supervillain, depending on her taste.

THE TROPHY WIFE

I AM A WOMAN ABOVE EVERYTHING ELSE.

—Jacqueline Kennedy

I n August 1959, a lovely young woman appeared on the cover of *Life*, her dark hair elegantly coiffed, a serene expression on her face and alert intelligence in her eyes. She is in sharp focus and strongly—though flatteringly—lit, and she's wearing a boatneck dress in what would come to be known as her signature color of lipstick pink. Behind her and to her left (the viewer's right) sits a handsome, confident man, who is soon to be president of the United States. He is slightly out of focus.

Known to the world as Jackie, Jacqueline Kennedy (née Bouvier) had an enormous impact on American style and culture at a time when the iconography of the American dream was at its height. Once her husband was in office, she did all the things a happy homemaker was supposed to do: she made her house a perfect setting for the prosperity of her family, she took her place at his shoulder, and she dressed with legendary good taste. Her image and wardrobe quickly came to have so much influence that one could love her or hate her, but not ignore her. She was the ultimate trophy wife.

There are certain well-behaved women who stand out in history as icons for a standard of living based in tradition and right-thinking, and Jackie was that kind of woman. One of the most visible, if not *the* most visible, women of the 1960s, she was the quintessential American woman. As partner to the most powerful man in the world, she was half

of the perfect couple, their faces emblematic of a fresh era promising everything from dignity and grace to affluence and intellectual accomplishment. The Kennedy White House was known as the new Camelot, the home of a king for whom the good of his country and the welfare of his people were his first priority.

Jackie was acutely aware of herself in this position, and was diligent about maintaining her sense of style. She kept a personal stylist on hand: Oleg Cassini, a dashing man who dressed stars, both officially as a movie costume designer and dresser, and unofficially as a designer whose clothing was worn by the rich and famous. (To ensure that there was no financial conflict for the president, Jackie's father-in-law paid for her couture wardrobe.) Cassini was a charmer, a handsome man who had dated many celebrities, as well as having been married to the breathtaking (and leopard-print loving) Gene Tierney. He appears to have been the kind of man to whom women would divulge their secrets, as he can be seen in many paparazzi shots of the day listening intently as women, including Jackie, lean in to speak in his ear.

The timing was perfect for a woman so astute about her appearance. Consumerism and the desire to be the perfect homemaker and shopper had been steadily growing since the end of World War II, after which it became a patriotic duty to aspire to a well-turned-out home, a well-stocked fridge, and a well-dressed family of four. Women had had to work during the war, but once the men came home, the ladies were expected to give up all that and let the men be the breadwinners while they kept the home sparkling. This sensibility was about to hit its pinnacle in the 1960s, the golden age of advertising.

In a 1959 automobile ad, an elegant blond woman and her blond daughter emerge from an elaborate theater bearing a poster for the ballet, apparently about to get into a 1960 gold Cadillac. They are wearing matching leopard fur coats, noted in the ad as specially designed by a

The timing was perfect for a woman so astute about her appearance.

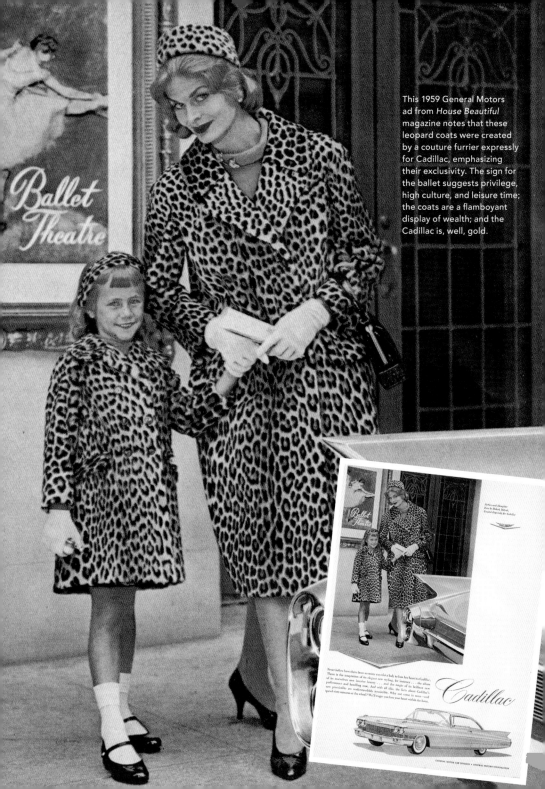

This 1959 General Motors ad from *House Beautiful* magazine notes that these leopard coats were created by a couture furrier expressly for Cadillac, emphasizing their exclusivity. The sign for the ballet suggests privilege, high culture, and leisure time; the coats are a flamboyant display of wealth; and the Cadillac is, well, gold.

prestigious fur company. It's the ultimate fantasy of the good life: wealth, culture, and family togetherness. The leopard fur indicates the ultimate luxury, as such coats cost as much as a small house at the time, and the idea of dressing a little girl in one just to match her mommy is an indicator that nothing is too good for their little girl. The mother is looking up into the camera as if greeting Daddy, who must be the ultimate good provider.

Leopard, cheetah, and jaguar fur was seen on famous flamboyant women as culturally diverse as Edie Sedgwick, one of Andy Warhol's superstars, inspiration for Lou Reed's song "Femme Fatale," and a symbol of the youth movement; Nancy Kwan, an actress known as one of the era's great sex kittens; Lena Horne, legendary jazz singer; and Elizabeth Taylor, movie star, scandaleuse, and wearer of some of the world's biggest and rarest jewels.

Nowadays, we are more likely to think of these daring women in leopard before Jackie, who appeared in a leopard fur coat in 1961. Yet her position was so impeccable, her image so flawless, that rather than she being tarnished by its extravagance and flamboyance, the coat was lent an aura of respectability. With her perfect hair, her perfect heels, and her perfect leopard-skin pillbox hat (perhaps the very one immortalized in Bob Dylan's snarky song "Leopard-Skin Pill-Box Hat"), some found her, well, too perfect. She set off a craze for leopard coats—genuine for the rich ladies, "looks like the real thing" for the less fortunate—that made it the emblem of mid-century chic for the next fifty years.

She was wearing her signature lipstick pink when, on a sunny November day in 1963 in Dallas, Texas, Camelot was shattered by a sniper's bullet, her husband shot while she sat next to him in the back seat of a Lincoln Continental convertible. Jackie wouldn't remove her bloodspattered pink suit for hours, saying, "I want them to see what they've done." Her poise and apparent resilience as she led the nation in their grief proved she was more than just a clotheshorse or trophy wife; she was a true First Lady of the United States. After her husband's death, she fled Washington for New York City and attempted to live a relatively private life with her children. She moved on, though certainly she would never

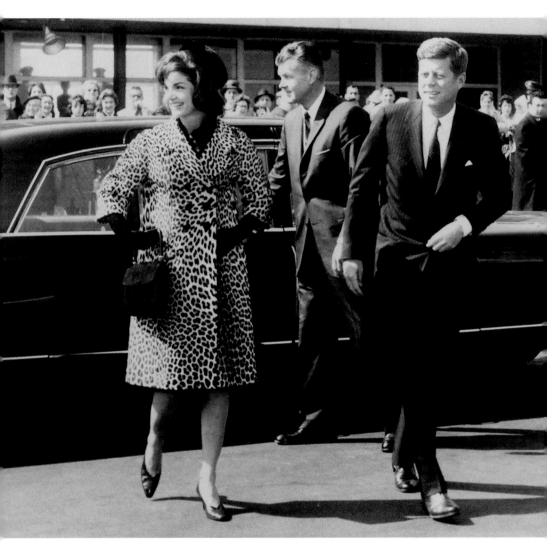

Above: Jackie Kennedy in her original leopard coat, the one for which Oleg Cassini assumed responsibility. It astonished the public to see the first lady in a coat that symbolized flamboyant wealth. *Opposite page:* Gene Tierney, a famous actress who was also married to Oleg Cassini, wore leopard print everything. She looks fresh and fetching in this full-circle skirt in the late 1950s.

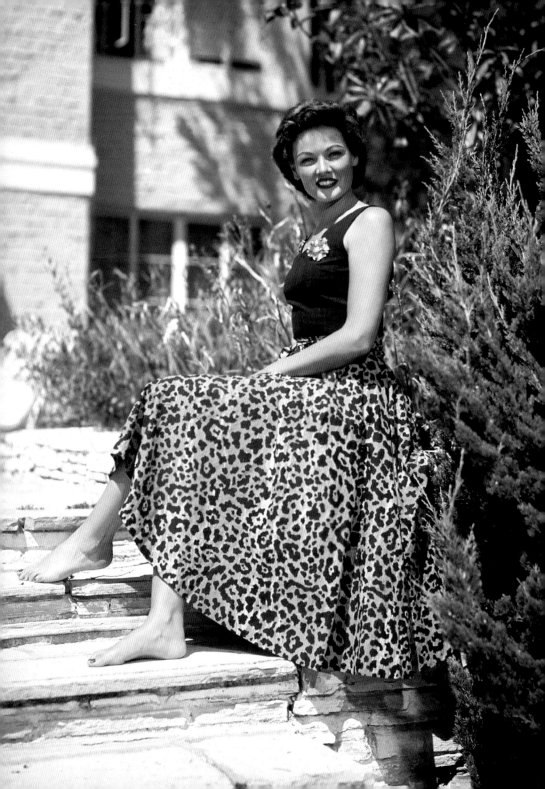

Jackie Kennedy and family with Emperor Haile Selassie of Ethiopia in the White House Rose Garden, 1963. This photograph was taken immediately after Selassie gave her the coat.

be the same after the horrors of the assassination. Throughout her lifetime, she had proven herself intellectually, employing her knowledge of other cultures and her gift for language while at the White House. After the death of her second husband, Greek magnate Aristotle Onassis, in 1975, she spent decades as a book editor, working on projects as diverse as Michael Jackson's autobiography *Moonwalk* and Joseph Campbell's *The Power of Myth*. Her celebrity followed her everywhere, however, as did memories of that leopard fur coat. From 1967 to 1968, not long before Jackie was to marry Onassis, stories about the coat appeared in newspapers, creating a series of small scandals.

According to an article in the *Los Angeles Times*, a Somali ambassador reported that in 1962, then prime minister Abdirashid Ali Shermarke had given Jacqueline Kennedy the gift of two leopard skins, which had been made into the fur coat that became an international status symbol. The subject of the gift had surfaced because the Somali government had, in 1967, offered a gift of similar value (described in some papers as leopard pelts, in others as an enormous diamond) to U.S. vice president Hubert Humphrey's wife, Muriel. Somali officers were confused as to why Mrs. Kennedy had been able to accept an expensive gift while Mrs. Humphrey could not. In fact, in the interim between the two first ladies,

regulations had been passed that prevented an individual representing the country to accept a gift exceeding a certain value as a permanent personal acquisition, though they could receive it for the state, to which it would then belong.

A dispute ensued about whether Mrs. Kennedy had used pelts received as a gift from Shermarke in the famous coat or whether it had been made by noted furrier Ben Kahn. A spokesperson for Mrs. Kennedy said that she didn't remember receiving such a gift from the Somali government, and a video from news of the day, which shows some of the gifts presented to the White House by Shermarke, doesn't show any leopard skins. However, Shermarke seemed sure that he had given them to her. While two pelts would not have been enough to make an entire coat, they could have been incorporated into one—if they were there. However, she is reported wearing the coat on a trip to India, which occurred before Shermarke's trip to the United States. Further, Emperor Haile Selassie of Ethiopia said that he was the one who had presented Mrs. Kennedy with the coat, and produced photos of her wearing it in the White House Rose Garden immediately after he gave it to her.

There was, of course, the matter of a border dispute between Somalia and Ethiopia and for which Shermarke had been courting President Kennedy for neutrality during his visit, which accounts for the newsworthiness of the dispute.

Examining photos in the Kennedy library and comparing the coat from 1962 to the coat in the Rose Garden, it's fairly easy to see that they are two different coats. Not only is the cut and sleeve length different, but the pattern of spots on the lapels is different.

While there is no newspaper consensus on what might have happened to the pelts Shermarke described, there is no doubt that Jackie Kennedy had had in her possession not one but two outrageously valuable leopard fur coats. What remains interesting is the idea of leopard skins as a symbol of goodwill from two different and obviously wealthy African rulers, one on the verge of war with the other, attempting to influence the global power of the United States in the personage of the First Lady. It's a testament to the language of clothing and the power of style.

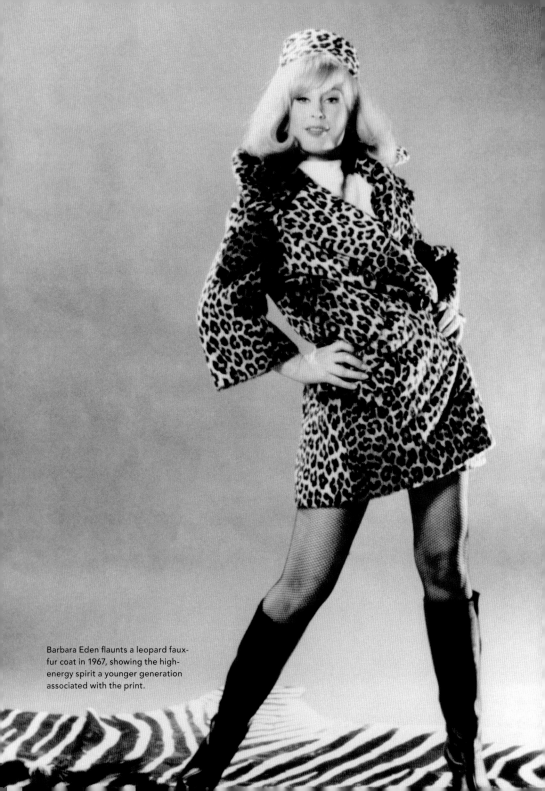

Barbara Eden flaunts a leopard faux-fur coat in 1967, showing the high-energy spirit a younger generation associated with the print.

As if Jackie's leopard coats hadn't created enough issues with this scandal, there was the problem of the leopards themselves.

The First Lady's coat had set off such a craze that nearly 250,000 leopards were killed for their pelts in the few short years following her appearance in it. Cassini, who had styled the coat for her, was so horrified by this development that he stopped working in fur entirely—a huge step for a high-end fashion designer. He became one of the world's most notable anti-fur crusaders, designing entire lines in an improved faux fur that he helped develop in an effort to encourage haute couture designers and wearers to work with those materials rather than animal skins. Although he published an entire book about his days of dressing Jacqueline Kennedy titled *A Thousand Days of Magic*, he didn't mention or show the coat in it. He became a passionate advocate for animal preservation, and even touted Viagra as a better alternative to elephant and rhino tusks poached and powdered and made into medicines for waning virility, though he never mentioned whether he had done a comparison test himself.

Most importantly, and blessedly, it was to be the end of the line for the leopard *fur* coat.

The fur-on-fur leopard coat was popular with fashionistas and entertainers from the 1800s until at least the 1970s. Here, twenty-first-century pinup model Ashleeta Beauchamp models a coat formerly owned by variety-show star Mitzi Gaynor.

ACCESSORIES: A SPOT OF DANGER

Leopard and other spotted furs had begun to appear more commonly on hats and muffs in the late 1800s. Usually worn with fur coats, these accessories enhanced the theme of wealth and sophistication by taking the pattern into the details. Primarily worn outdoors, and most often by celebrities, they made an impression on the general public. Accessories were more affordable, though still not cheap, and to carry a leopard muff made many women feel like a star.

Prestigious Cartier launched their Panthère line of jewelry in 1914, coinciding with the craze for keeping cats as pets. Their watches and brooches were particularly popular, and the company's artisans produced custom items for clients such as Wallis, the Duchess of Windsor, and María Félix. Their work was the gold standard for exquisite good taste and quality handiwork.

Unfortunately, not everyone had the money for it, but as jewelry began to be mass-manufactured, the panther motif appeared in affordable versions that anyone could wear on their lapel or the front of their hat.

In addition to jewelry, leopard-themed accessories became increasingly popular. In the 1920s and 1930s, of course, the femmes fatales promoted the pattern on matching hats, lapels, and muffs, giving off a luxuriously sporty air. By the 1950s and 1960s, the pattern printed on other materials had made its way into the fashionista's closet via shoes, belts, purses, and jewelry. Bob Dylan's 1966 song "Leopard-Skin Pill-Box Hat" presented an unflattering view of those who wore the iconic headpiece, but few were dissuaded by his disdain.

For women who couldn't afford the fur, or who loved the pattern but didn't want to be conspicuous, leopard print allowed them to enhance their wardrobe without spending a fortune or causing a stir. In the 1970s, with the fur no longer available, leopard print appeared less subtly on turbans, scarves, and platform boots, worn by those who didn't mind being a touch outrageous.

To this day, leopard-print accessories provide visual flair and allow the wearers to carry a bit of the cat's power to fortify their daily resolve, as if their familiars are traveling with them. There's nothing quite like wearing a basic black

Kate Spade offered a full range of leopard accessories in their 2017 LeopardLeopardLeopard collection.

or beige suit and looking down to see one's leopard-print purse or shoes: a little reminder that we are not entirely tamed.

Accessories are also helpful when the leopardess knows it's time for other people to be allowed to shine, but she wants her favorite print near her—it's a great way to be true to her flamboyant personality without taking up another star's space when that would be greedy.

Many fashion experts still say that just a touch of leopard print is the best option for most women who aren't comfortable going for the full wildcat effect. For the leopard-obsessed, it's merely a way of showing restraint. There's proof of power in acknowledging one's wild side with just a hint of the pattern, almost as if to say, "There's more where that came from."

THE BAD MOTHER

WOULD YOU LIKE ME TO SEDUCE YOU?

—Anne Bancroft,

The Graduate

Opposite page: Anne Bancroft stole the show in the groundbreaking film *The Graduate*, which showed boredom, frustration, and dysfunction at the heart of two well-to-do families.

J ackie Kennedy's coat was the beginning of the end for using genuine leopard fur, but it wasn't the only factor in the evolving reputation of the pattern during the 1960s and 1970s. While the First Lady's accidental politics were thought by some to be out of place, she managed to remain an icon of dignified womanhood. She was a dedicated mother, always at the hands of her children, and her air of gentility and wealth remained ever present throughout her public mourning. The sight of her in a leopard coat had been remarkable partly because of her self-control and conservative taste. She made the image of the trophy wife, so vulgar in the golden Cadillac advertisement, a matter of impeccable taste and pride. Those who had seen Elizabeth Taylor and Mitzah Bricard wearing leopard coats in the previous decades had not been thinking of them as homemakers but more likely as the wreckers of homes. Once Jackie wore it, however, leopard became safer to wear.

Enter the *bad mother*, who wore leopard print inside and out.

The bad mother trope, a warning against deviation from the ideal, should come as no surprise. During the 1960s, even women who loved being housewives and mothers and prized their roles as partners to their husbands began to chafe under their limited options. In spite of the veil of modernity, women's wealth was, by law, regulated differently than men's. The rising movement of feminism was called women's liberation because its proponents believed women needed to be freed. And what many

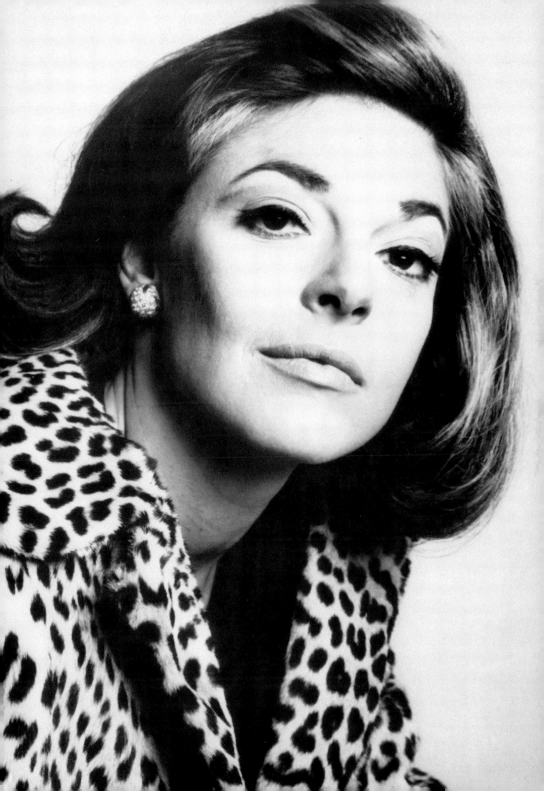

women wanted to be freed from was a culture in which the only power to be had was the secondhand power of a successful husband.

The ideal of womanhood, particularly white womanhood, that was on display—segregated from men, privileged to do all the work of a paid employee without any pay of her own, beautiful, serene, supportive, content to cook and clean (or direct the cooking and cleaning, if she was well-to-do), raise children, and be defined by the last name she had assumed—began to crumble under scrutiny. The children of the post-war generation were coming of age in the era of the civil rights movement and the Vietnam War, and they were not satisfied just to be grateful with paternal permissions and protection. They wanted to take on the world.

Betty Friedan's *The Feminine Mystique,* published in 1963, helped to bring much of this discontent to light. In 1957, she had interviewed her fellow Smith College alumni for their fifteen-year reunion and found that many of them were unhappy as housewives. The discovery that even the most privileged of trophy wives weren't satisfied set her off on a nationwide survey. She intended to write an article on the subject, but one magazine after another refused to publish it. After all, many of them were in the business of selling items to fill the perfect homes these women were supposed to be keeping, and the suggestion that shopping for dish soap and clothes dryers wasn't enough went against everything they meant to represent. So Friedan used her discoveries to write a book instead.

In *The Feminine Mystique,* she described the appearance of independent women in the media in the 1930s, depicted as having careers and independence. She discussed how early twentieth-century feminists fought to secure rights to education, voting, and freedom of choice in lifestyle for women. She rejected the (at the time) commonly accepted theory put forth by Sigmund Freud that nature had determined women's destinies to be caretakers and companions. She objected to the educational trends for women in the 1940s through the 1960s that had shifted women's education to better housekeeping. She attributed the requirement of women to be nurturers as a development of the world wars, after which people idealized the lifestyles for which they had sacrificed so much, and based the ideal of the American dream on a homogenized vision of home,

hearth, and family. Further, she described the way these limitations left women unfulfilled as a sign that this vision of home life was detrimental, rather than beneficial, to the happiness of families.

The book made Betty Friedan a household name and a staple on bestseller lists. It's regarded as one of the most influential books of the twentieth century, considered one of the catalysts for a new wave of feminism, and is believed to have been instrumental to the passage of the Equal Pay Act of 1963, which required equal pay for women and men doing the same work (although that goal hasn't yet been achieved). To date, it's sold more than three million copies. Fifty years after its publication, in 2013, the U.S. Department of Labor created a list called "100 Books that Shaped Work in America," and *The Feminine Mystique* was in the top ten.

The book must be critiqued for its narrow focus on middle-class white women even though the author would have known the civil rights movement was in full swing at the time. Friedan didn't acknowledge impediments to the vote such as poll taxes, literacy tests, and other tactics that effectively disenfranchised many black women of their era from their right to participate in elections until the Voting Rights Act of 1965, or the fact that Native American women had been prevented from voting in many U.S. elections until 1957. However, the book's influence on perceptions of women's work as housewives is beyond doubt. It shattered the concept of the "ideal life" promised not just to women but also to anyone who conformed. Patriarchy was, then as now, all stick and no carrot.

Many were quick to cry that women who objected to their places as housekeepers were ungrateful and that reading Friedan's book would ruin traditional families and their values. Others believed, like Friedan, that the unhappiness of women with underserved potential was more likely to cause strife at home, and that these women and their families deserved a bigger life.

In Mike Nichols's 1967 film *The Graduate*, Anne Bancroft played the ultimate destructively unfulfilled housewife, and became the iconic bad mother. We take her for granted now, but Bancroft as Mrs. Robinson changed the perception of the housewife satisfied with her lot when she

expressed a yearning for new opportunities and self-expression beyond the narrow world of the suburb. She suffered from being defined only in relation to the people in her life: neighbor, mother, wife. In an era when these roles defined the status, identity, and value of a woman, her rebellious behavior was inexplicable—unless one took Friedan's arguments into account. Her value was echoed in supposedly protective statements of value based on ownership such as, "That woman you just disrespected is my wife/daughter/mother," as if a woman without an identifiable owner could not merit respect.

Mrs. Robinson was glamorously shameless. She looked *fabulous*. She wore animal print in almost every scene of the film—from the metallic tiger-print dress with a sheer black overlay when she first attempts to seduce her neighbor's son to the leopard coat when they meet for the first liaison of their doomed affair.

Watching *The Graduate* now, it's remarkable how unlikable everyone but Mrs. Robinson is. She's the only character anyone would want to be, at least at the beginning of the movie. The film was one of the biggest hits of that year, and in description after description of it, she's the primary subject.

To be fair, Mrs. Robinson is far more charismatic than she is admirable. She speaks with assurance and smokes with the flair of a dame from 1940s film noir. She's funny, assertive, and charming. However, she's not a positive character, nor does she seem to be particularly happy. She's cheating on her tedious husband and interfering with her daughter's happiness; she's a proactive woman trapped in the submissive role of wife to a successful man, and she's acting out. While almost all of her decisions are reprehensible, she makes them with a sense of conviction and follow-through that most people would kill to have. She's absurdly predatory, but also deeply focused and knowing. Ultimately, her bad behavior is seen as a symptom of the dullness of her life, and her role validates the rage of the thwarted woman. If Jackie Kennedy's coat represented the pinnacle achievement as the wife of the man who ruled the world, Mrs. Robinson's leopard-print underwear represented the caged cat that inevitably turns on its master.

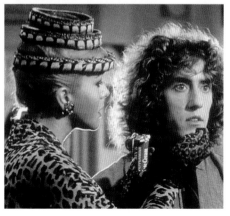

Top left: Anne Bancroft wears leopard lingerie in *The Graduate*. *Top right:* Katherine Helmond, in 1985's dystopic film *Brazil*, wears a shoe hat referencing Elsa Schiaparelli's surreal millinery. *Right:* Ann-Margret, in *Tommy*, 1965, and *above*, in the 1964 film *Kitten with a Whip*. She loved to play up the sex-kitten persona.

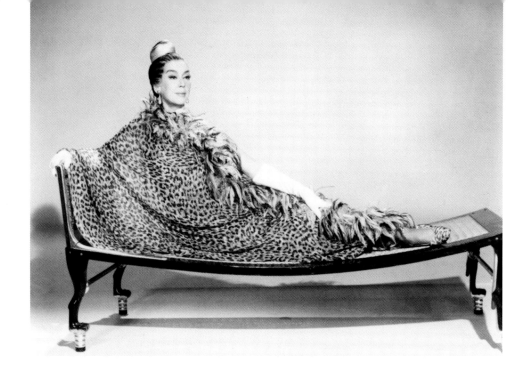

Rosalind Russell's character from the 1967 film *Oh Dad, Poor Dad, Mamma's Hung You in the Closet and I'm Feelin' So Sad* reclining in a James Galanos leopard-print muumuu.

The bad mother in leopard print appeared again in the 1975 movie *Tommy*, based on The Who's rock opera. The idea that a mother should have no need for romance or sex is in play as Tommy's mother, Nora, played by Ann-Margret, falls in love with a new man after her husband's presumed death in the war. It's assumed that Nora is simply too sexy to be a good girl. When her MIA husband turns out to be alive and returns unexpectedly, he's killed by Nora's new man while Tommy watches. Tommy is left deaf, dumb, and blind by the trauma of what he has seen and by being asked to keep it a secret. Nora's destructive female sexuality kills one man, turns another into a murderer, and yet a third into a sense-less mute. During a series of scenes in which she and her husband go out on the town while a pair of progressively abusive babysitters are left to torture hapless Tommy, she wears a variety of tight-fitting head-to-toe leopard-print outfits. Mother's pleasure is assumed to repeatedly endanger her son. Here the print signifies self-indulgence, greed, and hedonism, as echoed decades later by Peggy Bundy, the selfish housewife on the television sitcom *Married with Children*. In the end, Nora is sacrificed

to her son's enlightenment, but by then she has stopped wearing leopard print, so maybe she's a good woman after all.

Nora as the bad mother is, like Mrs. Robinson, the most driven character in the movie. Of everyone, she shows the greatest awareness of her needs and the most willingness to act to satisfy them. She is active rather than reactive. Her strong will is portrayed as a destructive influence and speaks to the popular paranoia of the day: the newly liberated women, it was commonly feared, would rather destroy her family than be someone of virtue.

Whether her character is feminist is relative to the needs of the women who relate to her or don't. She does, however, represent the need to self-actualize. Like women portrayed as goddesses in society in ancient Greece, she's lost without a pedestal. While women in ancient Greece were admired, they weren't allowed to vote or have their own money. For American women, the vote was not enough. This thread of feminism overlooked the needs of many, but it was a defining moment for standards of women's agency, those rights that were needed at all intersections of women's experience. Leopard print may have been tainted by the association with the supposedly bad mother, but to women who identified, it represented self-determination and freedom, frequently of the sexual kind and often simply of the will to have a life in addition to the home life.

Those who've judged a mother who still has sexual appetites and indulgences as a bad mother have underestimated her. A mother can be herself, whether that means to be a happy stay-at-home housewife or a flamboyant nightlife star, and still be true to her family. She doesn't give up all her other drives and identities simply by becoming a mother. Each woman contains many women and can fulfill many roles. Like the leopard, she adapts; but that doesn't mean she loses her ability to go where she has gone before, as if all doors are shutting behind her. It means her world can expand.

Female leopards are in charge of their year-round mating season. They may choose to have multiple breeding partners in their lifetime, and they initiate the mating process by brushing against males and smacking them with their tails. While generally solitary and territorial, leopards are excellent mothers, attentive to and protective of their young.

IS BAD TASTE A BAD THING?

—*Vogue*

hile Americans in the 1970s didn't invent bad taste, they came gloriously close to perfecting it. After the disappointments and tragedies of the post-war era— Kennedy's assassination; civil rights violence; the Vietnam War; and, early in the decade, Nixon's resignation—they were ready to have fun, whether or not it was a good idea. Cars were huge, hair was expanding, and double-knit polyester bell-bottomed pantsuits were taking over. So many things were happening in fashion that even venerable *Vogue* magazine threw up its hands and declared that there were no longer any rules.

A woman could wear just about any skirt length she liked, from the persistent miniskirt to the newly hip maxi, any time of day or night, and she did. While she was constrained in professional environments like schools and offices, where pantsuits were still not allowed and she almost always wore stockings or tights over her bare legs, she had significant freedom of choice. Showing a lot of leg might be considered tacky in some places, but it wouldn't get you arrested.

The word "tacky" was originally a noun, a Southern American colloquialism used in the early nineteenth century to refer to a small or inexpensive horse. There's a breed called the Carolina Marsh Tacky, though only a few of these horses remain. The word evolved to mean an

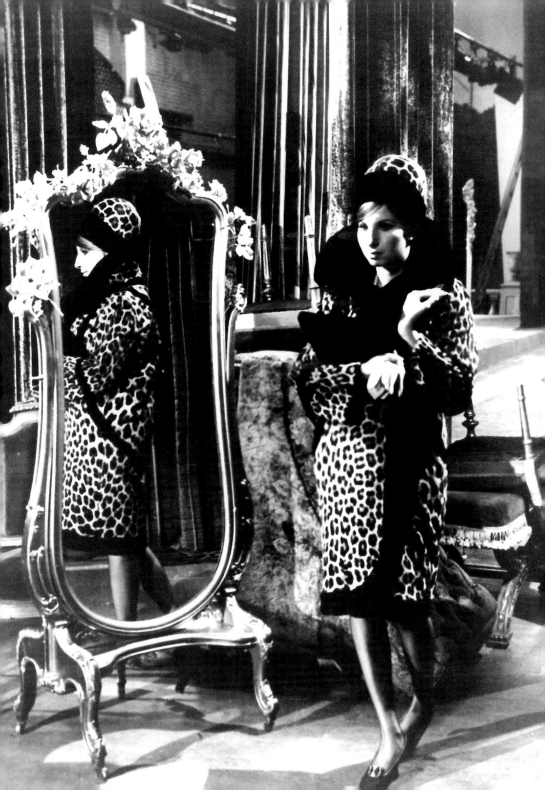

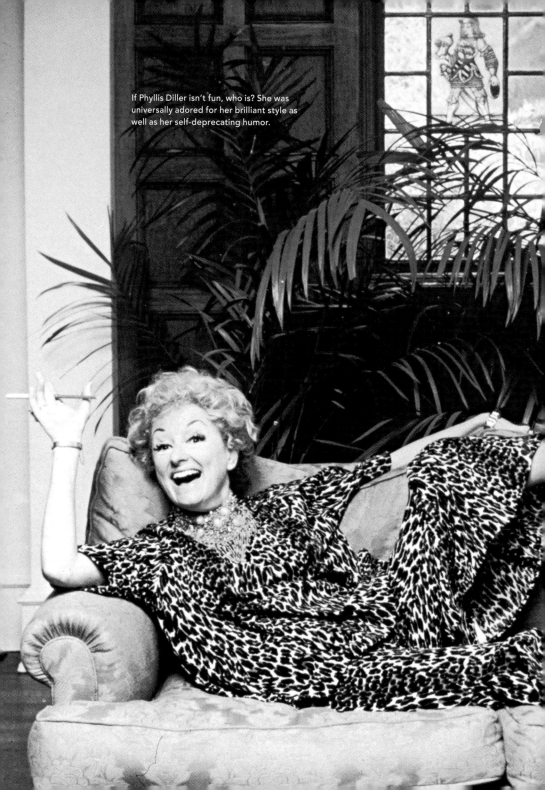

If Phyllis Diller isn't fun, who is? She was universally adored for her brilliant style as well as her self-deprecating humor.

ill-kept or ill-bred horse, then to mean an ill-bred person, and finally, by the mid-twentieth century, to become a modifier of the quality of items owned by or associated with that ill-bred man—the quality of bad taste.

To claim someone has bad taste is to make a statement of one's superior taste, as it requires good taste to be competent enough to observe bad taste. There's usually some kind of class statement explicitly or subtly included; tacky choices demonstrated a lack of culture, education, money, and possibly a moral deficit. A high price in and of itself does not ensure that a given item is in good taste. An expensive dress by a bad designer, or a good designer having a bad day, can also be tacky.

"Tacky" is what is too easily accessible to people either without resources or abusive of the resources they have. Tacky, as a concept, refers to the lack of cultivation or the resistance to taste, and more often than not refers to tastes that are not suitably conservative. That which is elegant can become tacky if it becomes less exclusive and more easily acquired, what one might call the promiscuity factor in fashion. A cheap knockoff of a fancy designer shirt can be tacky, even if the original was in the best possible taste—and clearly, it's in bad taste to rip off the designer in the first place. Tacky doesn't respect gatekeepers, and tacky tries too hard.

Furthermore, tacky is likely to be feminine, ethnic, queer, deviant; not manly, not practical, not businesslike, not serious. Tacky, like hell, is always other people.

High fashion became increasingly less concerned about good taste. In the 1970s, the fashion industry began to lose its authority over what was in and what was out. Richard Selzer (aka Mr. Blackwell), the creator of Blackwell's "Ten Worst-Dressed Women List," an annual compilation of the celebrities who perpetrated the worst

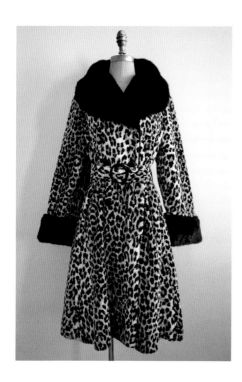

This coat from La Bruja Vintage is a perfect example of the fun new fur coats that dominated 1970s outerwear. Note the return of contrast fur at the collar and cuffs, as seen on early twentieth-century coats.

fashion crimes, was no longer feared. Celebrities found themselves amused to be on his list, including Dolly Parton, famous for the saying, "It takes a lot of money to look this cheap," who wrote him a personal note of thanks for the recognition. Furthermore, Blackwell was responsible for the first televised fashion show in the 1960s, thereby subjecting high fashion to the critique of anyone who had access to a set and putting all in the front-row. This was part of the democratization of fashion, a trend that had been accelerating since the sewing machine was invented.

So what made the 1970s so tacky? Options. At no time and in no place had any population ever had the number of options, especially when it came to clothing, that Americans gained in the 1970s. Shopping malls, those centers of community and suburban culture, were headed toward their 1980s peak. While shopping areas and markets have existed since the dawn of trade, and malls have been documented since ancient Rome, the enclosed shopping mall became a specific phenomenon in the United States during the twentieth century.

Before the shopping mall took over, brick-and-mortar shopping had generally been centralized in whatever was the downtown section of a given town or group of towns, and had an air of urban sophistication about it. The growth of the shopping mall moved shopping closer to the burgeoning suburbs.

For those interested in exclusivity and exceptionality, a shopping mall is the worst, filled with racks of identical clothing open to be pawed and tried on at will by all and sundry. A mall was a place where anyone could go and work in a tacky clothing store and buy a tacky shirt with their tacky employee discount. The pleasure these tacky people took in

their purchases appeared to be irrelevant, according to arbiters of good taste, to whether they were good clothing choices, as the shoppers lacked sophistication and education about the quality of their clothing, and the ease of access to the items they bought was the main reason they were tacky. And, of course, the mall shoppers had the good sense not to care about the arbiters of good taste.

The more options poor people have, the more invested elitist wealthy people are in distinguishing themselves from the aesthetics of non-wealthy, average people, who just happen to look great in leopard print because *everybody* does. While they couldn't enforce sumptuary laws in order to make sure poorer people couldn't look like they could, they could support the creation of ever-more expensive and elite clothing, and they tried.

Everyone else just ignored them. Leopard print was at the forefront of the resistance to good taste. In fact, leopard print was employed so thoroughly and so shamelessly in the 1970s that today many costume-in-a-bag outfits that aim to re-create the seventies that don't really have many of the key structural characteristics of 1970s clothing manage to work simply because they are executed in leopard print. Anyone who wanted to could wear leopard print, and did. It showed up on faux fur coats, print shirts, dresses and skirts, pants, underwear, bikinis, purses, shoes, hats, and more. There was no longer the comparison to the outrageously expensive genuine fur; leopard print was on its own for the first time, and it was winning.

While many people wouldn't have wanted to think of themselves as tacky, even if they wouldn't have changed their tastes in order to avoid it, others were proud of it. This was the era in which "camp" came into its own.

To be campy is, among other things, to be tacky on purpose. Campiness is considered, not entirely without snobbery, as a self-aware version of tackiness. Campy is smart tacky, glamour with an ironic twist. Campy is always too much, whereas tacky is somehow not enough. Campy embraces the detestable with affection, as an actual aesthetic. The word "tacky" implies that the person so designated had failed in their goal of

being tasteful, whereas the word "campy" implies they have succeeded in their goal of being distasteful.

In addition to the downfall of the conservative trophy wife, the resistance to prescribed good taste had begun in the 1960s when youth demanded their own recognition. Not unlike the flappers of the 1920s, the teenagers and young adults of the 1960s set a tone for what was fresh about the era. They challenged adults on every front. The 1950s had promoted consumerism as the source of happiness, progress, and problem resolution: a belief in the right job, the right house, the right product. Much of the advertising had a thread running through it, the promise that leading the right life by respecting the right kind of authority would lead to the right heaven. And before heaven, there would be the perfect retirement, a well-heeled future in which everyone played golf and the prosperous offspring of right-thinkers visited on the (Christian) holidays, generally for the purpose of overeating.

However, while the increased access to media had led to the golden age of advertising and resulting standardization of consumerism and conformity, it had also made possible the exposure of the dissatisfaction that lay beneath, as with *The Feminine Mystique*. Fashions of the 1970s did not protest so much as disregard authority.

Leopard print became more closely associated with several self-indulgent identities: the seductress, the exotic, the fun-lover, and the adventurer. Having any identity at all, being willing to stand out, was part of the essence of tackiness; good taste was meant to blend in. Women were, then as now, criticized harshly when they spoke with conviction about anything but supporting family and nation. The best thing they could do was be seen and not heard, or at least appear to be serious people. Women in leopard print were having none of that.

Fashion had begun to trickle up from the streets as well as down from fashion authorities. The popularity of youth culture and the quirkiness of their style were sources of fresh ideas for fashion designers. Coolness—in the sense of confidence and ease—came from youth and from marginalized cultures, particularly black cultures, as when jazz and dance from Uptown New York City and Chicago had influenced popular

culture. Youth became a cultural force to be accounted for and reckoned with. Furthermore, youth culture became a market, and if leopard print as nonconformity would be sold, plenty of young people were willing to buy it.

The fashion store Biba, created by clothing designer Barbara Hulanicki, had been popular in the swinging London of the 1960s, when London's high streets became the center of a sensational movement toward experimental fashion that embraced designers such as Paco Rabanne, who worked in unusual fabrics such as metal and plastic; Emilio Pucci, who created complex large-scale patterns; and Mary Quant and André Courrèges, who were each in their own way responsible for the earth-shaking phenomenon of the miniskirt. Originally a small corner store selling only one dress to very young women, when Biba created its own multilevel department store in the early 1970s, it was able to retain its youth appeal in part by selling reasonably priced clothing and home items in a theatrical setting with an old-Hollywood-style art deco interior. Their food store made fun, whimsical references to pop art, like stacking soups in a display based on Warhol's soup cans. It featured its own restaurant, the Rainbow Room, where both rock stars and regular shoppers hung out. It had a rooftop garden with flamingos. It also had an animal-print lingerie room, a big, round leopard-print bed in the center of one of the levels, and a spectacular communal dressing room covered with a cheetah-print motif, designed by Steven Thomas of Whitmore-Thomas Design Associates.

The popularity of Biba that had exploded with their very first store in the 1960s reflected the burgeoning youth market of the decade, which persisted into the seventies and beyond. While trophy wives and bad mothers had been attending to rich and powerful men,

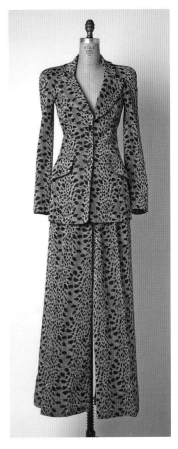

This pantsuit was designed by Biba founder Barbara Hulanicki in 1972 and sold at the legendary London department store Big Biba. It makes reference to the drapey fabrics of the 1920s and 1930s as well as the stylish suits of the 1940s, but brings it all together in a uniquely 1970s style.

their children were resisting their lifestyles. Some resisted literally, by protesting in marches and other civil rights actions or by dropping out of the job market in an attempt to buck the system. Others resisted by creating or wearing fashion, both new and old, that was impractical or simply intolerable to adults. Leopard print could be their way of playing against the leopard fur that was so expensive younger people generally could not afford it—and hence by the 1970s became associated in many of their minds with the restrictive social structures of the 1950s as well as with endangerment of animals.

Some of Biba's most memorable fashions included its fresh way of using animal prints, many of them in women's suits. They used the two-piece professional suit as a basis for outfits that managed to be both outrageous and polished. While the garments were clearly intended to be chic—think Katharine Hepburn dressed in a suit in the 1940s—they also, like Hepburn's suit, referenced the male Western suit that was becoming the global standard for businessmen, which Western colonizers implied all serious businesspeople must either wear or make a statement by not wearing. In the 1960s, Rudi Gernreich, who had designed the first topless bathing suit, took the idea of matching leopard-print pieces to the next level, combining space-age garment shapes with animal print on outfits that covered a wearer's body, legs, hands, head, and even faces. In the 1970s, animal print was presented in more familiar silhouettes. Women were determined to literally wear the pants as well, not just casually but also in the office. This suit combined layers of power: the power of the present over the past; the power of a woman to wear clothing that suits her convenience; the economical power of a woman to work and earn her own money; and the power to choose what to wear. It wasn't long before women were able to wear, if not leopard pants, pantsuits to the office, and several decades later the pantsuit would become the symbol of the first major party female candidate for president of the United States. Even in the ostensibly frivolous world of London fashion, women's determination to have their power acknowledged was becoming clear.

Of course, high-fashion designers still figured out ways to keep some leopard print for themselves. It was too good to give up. Among

Opposite page: The seven-story Big Biba store in London used several big-cat prints to create an environment of fantasy and luxury. Its leopard-and-cheetah interior and artwork was designed by Steven Thomas of Whitmore-Thomas Design Associates.

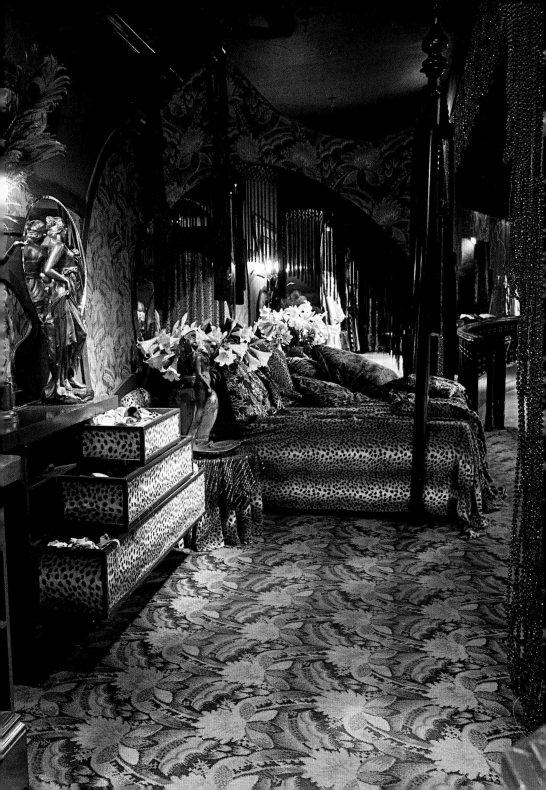

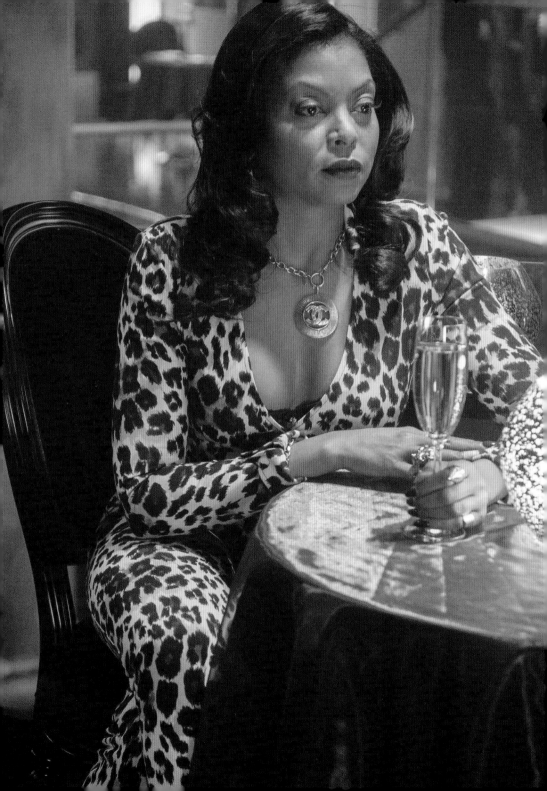

them was Yves Saint Laurent, who got his start in Dior's atelier. When he went out on his own he continued to share Dior's affection for the pattern and became well-known for his use of leopard burnout velvet, which continues to appear in Yves Saint Laurent designs today. He created beautiful high-end jackets and dresses in leopard-patterned flowing fabrics that echoed Dior's 1947 goddess-dress design.

However, the 1970s designer with the most direct influence on how leopard print is worn in the twenty-first century is probably Diane von Furstenberg. In 1976, she began marketing her wrap dresses, figure-hugging jersey pieces that managed to be both easy to wear and office-right, at least for administrative assistants and fashion editors if not for the then-rare female CEOs. The dress appeared on Upper East Side mavens as well as on the highly charged dance floor of Studio 54—the hottest and most exclusive disco in the world—where she could be seen in her leopard wrap dress chatting up Andy Warhol. Von Furstenberg hinted that the dress had been purposely designed to go from an all-nighter at the club to a walk of shame to the office, possibly without sleep but with plenty of polish. It was a little naughty, sure, but not tacky. Leopard print is so awesome that the elite and wealthy couldn't give it up altogether.

Despite the best efforts of the era's high-fashion designers, the 1970s have remained the source of much tacky nostalgia. Tacky, as time has proven by the affection people continue to have for it, is often where the imagination runs free, where the heart is, where the soul is, and where the fun is. However, the fun was just beginning, and the 1980s would take it further still.

Opposite page: Diane von Furstenberg created the ultimate easy outfit for tough women when she designed her silky knit wrap dress. Today, DVF's signature wrap is produced in tops, long and short dresses, and jumpsuits, and its timeless shape has been worn by powerful women everywhere, such as Cookie Lyon, played by Taraji P. Henson on *Empire*, pictured here in 2015.

THE ARBITER OF GOOD BAD TASTE

Filmmaker John Waters has embraced bad taste like no one else. Born in 1946 and hailing from the mean streets of Baltimore, he celebrated every kind of outsider—from the glamorous to the misfit—and made them unexpectedly lovable. His 1972 film *Pink Flamingos*, not his first but certainly the most recognizable of his early films, horrified unsuspecting viewers, which delighted him. He gained an immediate fan base who wanted to see the subversive, the revolting, and the outcast, which he managed to present with a tender familial affection while not obscuring any of their worst traits.

He made a star out of Divine, an over-the-top drag queen with no fear about doing shocking things onscreen, and who had, like Waters, a tenderness for the rejected that made him irresistible no matter what he was doing. He portrayed larger-than-life women in tight clothes with big hair and loud makeup and obsessions with sex and garish fashion.

It's almost hard to say whether Waters was drawn to leopard print because it was so tacky or whether it became so tacky because of the way he used it, but when Divine appeared in the posters for the 1974 film *Female Trouble* in a huge black wig, devilish brows, and a one-shouldered neon leopard-print dress, it set a new standard for how the print was perceived. It made such an impression that when Waters published his memoir *Shock Value*, in 1981, the cover of the book featured a similar print. The subtitle of the memoir is *A Tasteful Book About Bad Taste*. And it's delicious.

Opposite page: Drag queen Divine (aka Harris Glenn Milstead) was film producer and director John Waters's signature star, given the tagline of "The Most Beautiful Woman in the World, Almost." Divine reigned supreme over the Waters oeuvre until her death in 1988.

FEMALE

TROUBLE

avec

Divine

EDITH MASSEY
DAVID LOCHARY
MARY VIVIAN PEARCE
MINK STOLE
COOKIE MUELLER

Un film écrit et réalisé par

JOHN WATERS

I WANT MY LEOPARD PRINT

MY WEAKNESS IS WEARING TOO MUCH
LEOPARD PRINT.

—Jackie Collins

MTV (Music Television) aired its first music video, "Video Killed the Radio Star" by the Buggles, on August 1, 1981. It changed the way a generation experienced music—and made the avant-garde approach to fashion available to all.

Weekly music and variety shows have been part of television since its early days, having a viral effect on culture since the beginning. Lawrence Welk, whose television show ran from 1951 to 1982, was an early adopter, creating family fare with dancers, music, and his signature bubbles. Variety shows were a staple of network television, with hosts including Milton Berle and Ed Sullivan introducing every kind of performer from the established singers, comedians, dancers, and magicians to the newest stars, child prodigies, and animal acts.

Cher's show reigned supreme over variety shows in the 1970s, with spectacular costumes; famous guests, including Bette Midler and David Bowie; shamelessly cheesy comedy; and her own characters. Of special interest to lovers of animal print was her lovable portrayal of a middle-aged woman named Laverne, who wore her hair in 1940s pin-curl bangs and dressed in a tiger-print catsuit belted over body padding that established a less athletic figure than Cher's, and metallic mules that appeared to be from Frederick's of Hollywood. The outfit was definitely tacky, but the

character seemed crafted with affection for a woman who was happy to stick to the style of her salad days. Though Laverne rarely wore anything else, on at least one occasion she switched to a jaguar-print dress to perform with another variety show favorite, Flip Wilson's charismatic Geraldine.

In addition to variety shows featuring music and dance, weekly shows featuring top hits were popular from the 1950s and onward. *American Bandstand* (1952–1989) and similar local shows led the pack, while *Soul Train* (1971–2006) made its line dance the only one that mattered. Other countries had their own versions, such as Britain's *Top of the Pops* (1964–2006), many of which went international. *Don Kirshner's Rock Concert* (1973–1981) featured live performances, beginning in its first episode with the Rolling Stones. The format made its way into children's television as well, with cartoons based on famous bands such as the Jackson Five, and even a fictional girl group dressed in cat print, Josie and the Pussycats.

MTV was the first entire channel dedicated to music—specifically, rock music. Bands were already occasionally producing something like music videos, giving MTV something to play that first day. However, making a music video was far from a requirement for any recording artist, and most of the early videos were clips from variety shows, used as filler or novelty bits. When MTV started, they had only about 130 videos in their library, supplemented with MTV journalists who talked about the rock 'n' roll news of the day.

The philosophy behind MTV's music journalism was based on *Rolling Stone* and *Creem* magazines, a passionate rockist philosophy that treated rock 'n' roll and music criticism as legitimate cultural material. While

signature music has always been an accompaniment to subcultures and youth movements, it had never been presented in such detail before. By the time MTV came along, commercial radio stations were curating music to help support the advertising and the intended marketing groups, rather than trying to bring new and exciting music to their listeners. The airwaves were relatively free of aggression and the avant-garde, packed instead with the arena rock of bands like Boston, Foreigner, Journey, and Styx. The punk explosion in Europe, usually presented as a curiosity rather than the music of a movement adopted by young and disenfranchised protesters, reached only a few college station devotees in the United States before MTV, unless it was being ridiculed on the news.

Young people watching MTV knew it didn't sound like the predigested music on the radio. They knew it was theirs, and they adopted it with fervor. New wave and punk bands, which were politically and visually stimulating, began producing videos immediately.

Not everyone was pleased with the demand to produce videos. Many said that the visual format forced record companies to favor style over substance. Rick James and David Bowie called out the channel for the whiteness of its mostly English rock performers. Michael Jackson changed all that with the release of his album *Thriller* in 1982, destined to become the biggest selling album of all time, which made Jackson not only the King of Pop but the King of the Music Video. He could sing, he could dance, and he looked amazing. The video for the single release of "Thriller," featuring a loose horror movie plot and dancers dressed like zombies, set a new standard for music videos. And, wouldn't you know it, his girlfriend in the video wears a leopard scarf.

Rap and hip-hop videos began to gain more mainstream recognition and make their way into the MTV rotation as the network caught on that rap, like punk, was a powerful aesthetic. Artists wore leopard print as a connection to its history of use in luxury and high fashion. R&B divas En Vogue, in their hit song, "Free Your Mind," said with disdain, "You really think the price is high for me," referring to the assumption that they couldn't afford the high fashion they admired because of their appearance—and specifically, their blackness. When hip-hop became

even more visible in the late 1980s and 1990s, wearing expensive clothes was itself a form of resistance to stereotypes about the status of young black people.

Musicians wore leopard print on MTV like it was going out of style, which of course it wasn't. Campiness was half the fun of being a rock star. Camp, as an aesthetic, exploits gender, and leopard print's association with outrageous feminine behavior made it a perfect fashion subversion for male rock stars. David Bowie, Jimi Hendrix, Prince, Iggy Pop, Rod Stewart, Marc Bolan, and Little Richard all wore the print. Rock 'n' roll, while not historically friendly to women, nevertheless championed sexual freedom and explicitness in a way that inspired women. The fervent attraction many women exhibited toward androgynous, often openly bisexual rock stars belied the idea that macho is the only style of masculinity women can find attractive. The male rock star in leopard print was a different kind of macho; he seemed to be saying to the world, "You can question my masculinity, but I've got women waiting in line." He had a

Left: In the 1970s, the animated TV show *Josie and the Pussycats* gave young girls their own band of independent musicians and crime solvers to emulate.

Right: A lightweight faux-fur Norma Kamali tailcoat from the 1980s reflects the aesthetics of circus finery or faux nobility so popular in clothing influenced by MTV.

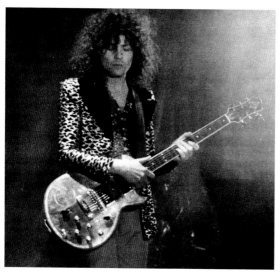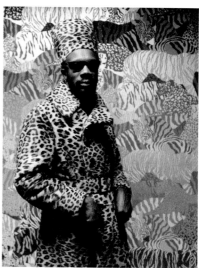

shamelessness about him that some women not only found desirable but also aspired to. For rock stars in the 1970s and 1980s to put their sexual orientation in question was bold in an environment in which homophobia was still legal. Perhaps women found parallels to the limitations on their sexual freedom in a way that made them want to embrace those men. Whatever the case, animal print certainly didn't repel them.

Camp was embraced in a different way by punk, new wave, and post-punk rockers, who were attracted to its disgrace as John Waters had been. Punk rock was aggressively anti-respectability. Post-Vietnam and Kent State-massacre youth had every reason to resist the authority of a government that didn't seem to value their lives and seemed to have hostility toward their attempts to make a better world. Fashion trends had been trickling up from the streets in ways it never could have before, when people without wealth wore clothing almost exclusively for function and owned very few garments. Designers cultivated knowledge about what inventive kids were wearing to signify their allegiances to various sub-cultures, and punk rock in its early days was a prime influence.

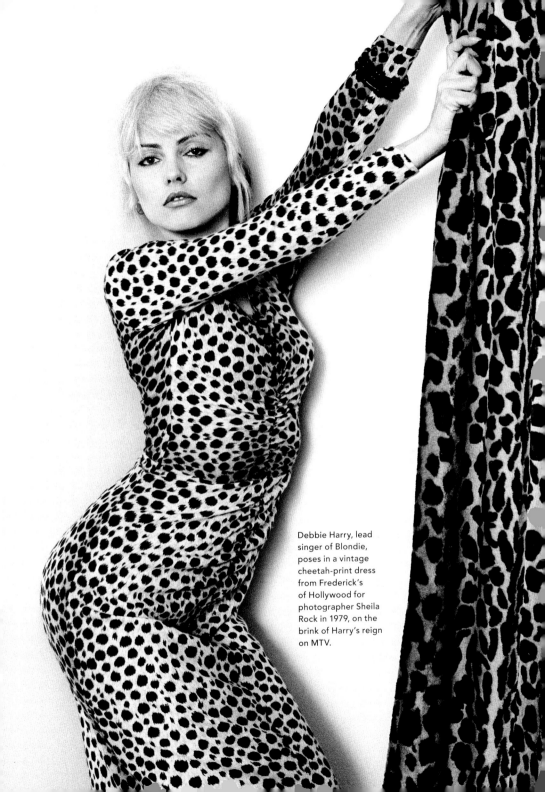

Debbie Harry, lead singer of Blondie, poses in a vintage cheetah-print dress from Frederick's of Hollywood for photographer Sheila Rock in 1979, on the brink of Harry's reign on MTV.

The punk movement bridged the 1970s to the 1980s. Punk was more open to female artists than any other form of rock 'n' roll had ever been. Wendy O. Williams, a former sex worker, chainsawed her way through onstage sets in a Vanity Fair jumpsuit worn backward with duct tape over her bared nipples. Grace Jones wore a tiger-print bodysuit with leopard-print gloves, and was photographed in nothing but leopard-print gloves on a tiger-print sofa. Nina Hagen, known as the Godmother of Punk, set her spectacular four-octave vocal range against rock 'n' roll while she wore leopard and cheetah print. They wore it to signal their rebellion against respectability and good taste, terms frequently used against women. They knew, in ways fallen trophy wives wished they had known, that being respectable wouldn't really pay off in safety and prosperity, and they rejected it with a passion.

Almost simultaneously, the print became associated with the kitten at play. Leopard print was the party print. Cyndi Lauper wore it in the beloved video for "Girls Just Want to Have Fun." Because it was on television, it didn't stay in the subculture. Pop star Madonna wore the pattern on jackets and leotards, and whatever Madonna wore, all the young girls wore—the malls were full of mini Madonnas. With her, an additional meaning began to layer onto the print. She had a rollicking pinup aesthetic that was openly, fearlessly, even aggressively sexy, but also gave the impression that she could take or leave anyone, that she wasn't about to get serious.

Hot on her high heels was a music trend that would inspire enormous passion in both its supporters and its detractors: hair metal. The music was brash, and the fashion was packed with attitude. Bands like Poison and Mötley Crüe teased their hair and wore the tightest pants rock 'n' roll had ever seen, prompting Nigel Tufnel, in the rock parody, *This is Spinal Tap*, to say, "They see us onstage with tight trousers and we've got, you know, armadillos in our trousers." Band members frequently wore leopard-print spandex pants and headbands and open leopard-print shirts. Although many of them were excellent songwriters and musicians as well as dangerous hellions, they were often subjects of ridicule to their detractors because they saw them as cartoon characters. As we know, style does

"THE FUNNIEST ROCK MOVIE
EVER MADE."

"HILARIOUS...SENDS UP WHAT THE
BEATLES STARTED WITH 'A HARD DAYS NIGHT.'"

"DON'T MISS IT...ONE OF THE FUNNIEST MOVIES"

THIS IS
Spinal Tap

CHRISTOPHER GUEST MICHAEL McKEAN HARRY SHEARER ROB REINER
JUNE CHADWICK TONY HENDRA & BRUNO KIRBY

NEWS

not indicate an absence of substance. And the women who flocked to them were also wearing leopard print.

It was an era of more. Leopard print began to appear everywhere, in every color, spurred by the increasing speed of fashion production and the wide distribution in malls. The economic boom of the early 1980s meant everyone was shopping—with leonine manes of really huge hair. The credit card as we now know it, a piece of plastic connected to an unsecured credit line, came into common use. Closets became enormous. California Closets originated in 1978; its custom-designed interior shelves, chests, and levels of hanger racks became widely available just in the nick of time.

As people made more space for it, an encouraging aspect of the leopard-print phenomenon became more obvious: it wasn't changing meaning as much as it was accumulating meanings.

Left: The promotional poster for "mockumentary" *This Is Spinal Tap* says it all: it wouldn't have been 1980s rock 'n' roll without leopard pants. (Full disclosure: the author has performed with Spinal Tap as a dancer for their song "Big Bottom.")

Right: Cindy Crawford rocked the mic while hosting MTV's *House of Style,* 1989–1995.

No matter how cheap it got, it was still prominent in high-end clothing lines, and still a signifier of luxury. The ultimate fashion television series of the decade, the nighttime soap opera *Dynasty*, was styled primarily by Nolan Miller, who recognized leopard print's value as an indicator of sophisticated ferocity. The stunning women on the show, most notably Joan Collins as Alexis Carrington and Diahann Carroll as her nemesis, Dominique Deveraux, broke the mold of female sexuality by being gorgeous and desirable past their forties. They were wealthy, powerful, glamorous, devious, and rowdy, and let their claws out in catfights that raged from one end of the room to another.

Alexis Carrington was known for her slinky dresses and big furs, both real and faux, including cheetah and lynx, and was photographed for the cover of *TV Guide* in a dress that appeared to be a sequined version of the one worn by the femme fatale in the 1956 movie *Invitation to the Dance*. She also represented the 1980s version of the bad mother, but she was such an unrepentant villainess it was difficult not to root for her over her pristine blond rival, Krystle Carrington. The man over whom they fought, Blake Carrington, scarcely seemed present when surrounded by these energetic forces of female determination.

It was also the era of the power suit for women as they began to dress for success to go up against men—and sometimes one another— in the high-stakes world of finance and corporate culture. They wore big shoulders with slim skirts, emphasizing the focus on their upper bodies, and often wore geometric haircuts. Leopard print appeared on their purses and shoes as they accepted the predatory nature of the world they were entering. Wall Street was booming—at least, until the crash of October 1987 known as Black Monday—and, after all, Gordon Gekko had told them that greed was good.

Aerobics ruled the 1980s, and so did spandex. Leopard print was one of the most popular prints for fitness, partly because of its traditional association with sideshow strongmen and partly because it echoed the strength of superheroes and villainesses such as Catwoman and Cheetah.

Making her mark as everyone's favorite bitch, Joan Collins played the devious, shameless, and extravagant Alexis Carrington, the leopardess who never changed her spots, on nighttime soap *Dynasty* from 1981 to 1989. Her sister, Jackie Collins, a legendary author of raunchy romances, was also known for wearing leopard print.

The print also began to appear in various hues, often extremely stylized. Dangerous cats became juxtaposed with candy colors, not unlike the way early 1980s pop songs juxtaposed angst-ridden lyrics with catchy dance music. By the end of the decade, music videos were a matter of course and animal print was welcome everywhere, yet it was still treated like a novelty.

MASTER OF LEOPARD PRINT

Despite a short career, Patrick Kelly was one of the most important new designers of the 1980s, and was a genius with leopard print.

He is one of fashion's Horatio Algers. Born working class in the American South, he worked his way through college, studying art at Jackson State University and then at Parsons School of Design in New York City, employed in food service while also managing to produce and sell his own clothing designs made at home on his sewing machine.

Supermodel Pat Cleveland, seeing his struggles in New York City, encouraged Kelly to move to the center of fashion: Paris. An anonymous patron sent him a ticket, and he was hired to dress dancers at Le Palace, a ritzy nightclub. He had interned as a window dresser for Yves Saint Laurent in Atlanta, Georgia, and the YSL organization welcomed him in Paris by sponsoring Kelly for his own fashion house. He was the first American and the first person of color to become a member of the Chambre Syndicale, an organization responsible for the management of haute couture in the French fashion industry since 1868. He was intent on increasing diversity in fashion and made sure models of color and women of various ages were prominently featured in his fashion shows and campaigns.

He favored boldness and used plenty of color. He often covered his designs in buttons and grosgrain ribbons, and fearlessly employed some chal-

Patrick Kelly used leopard print innovatively in modern silhouettes. His styles from the 1980s remain as desirable and wearable as ever, and his vintage pieces are still available on high-fashion resale and auction sites such as Augusta Auctions, which sold this one in 2016.

lenging (and controversial) visuals, such as golliwogs and black tar baby brooches. He said his creations and his presentational style were based on his love for women, which came from his admiration for the women of his childhood as well as icons Josephine Baker, Coco Chanel, and Elsa Schiaparelli. He told *People* magazine, "At the black Baptist church on Sunday, the ladies are just as fierce as the ladies at Yves Saint Laurent's haute couture shows," and he managed to combine the two styles with aplomb.

He presented collections from 1985 until he passed away in 1990. Though his career was cut short, his influence continues to be felt. He has been honored in multiple exhibitions: The Brooklyn Museum mounted *Patrick Kelly: A Retrospective* in 2004 and the Philadelphia Museum of Art mounted *Runway of Love* in 2014, based on his playful and affectionate approach to fashion. The Museum at Fashion Institute of Technology featured him in their 2016–2017 exhibit *Black Fashion Designers*, which included video of black models who worked with him discussing the importance of his inclusion of models of color to both them and the industry at large.

SUPERMODELS & STRIPTEASERS

I NEVER MET A LEOPARD PRINT
I DIDN'T LIKE.

—Diana Vreeland

I n the October 1990 edition of U.S. *Vogue*, Linda Evangelista famously declared that she didn't wake up for less than ten thousand dollars a day, and the era of the supermodel was official.

Supermodels have been present throughout modern media, including legendary art models such as Audrey Munson, born in 1891, whose form and face are featured in statuary on some of New York City's most hallowed structures, including the Pulitzer Fountain, the Manhattan Municipal Building, and the New York Public Library; Florence Wysinger Allen, born in 1913, who modeled for modern artists, including Mark Rothko and Diego Rivera; and famous fashion models like Suzy Parker and Twiggy, some of the peak models of their eras in the 1950s and 1960s, respectively. However, the impact of the late-twentieth-century supermodels established a new way of looking at fashion and models as celebrities.

Supermodels became so famous that the general public knew them by their first names: Christy, Cindy, Claudia, Linda, Naomi, Tatjana, Tyra, and Yasmeen among them. The idea of a supergroup of beautiful women took on a special luster, and they posed together in photo after photo in influential magazines from *Vogue* to *Rolling Stone*. Perhaps most memorable, several of them formed a kind of ensemble cast in George Michael's music video for his 1990 hit "Too Funky"—a video

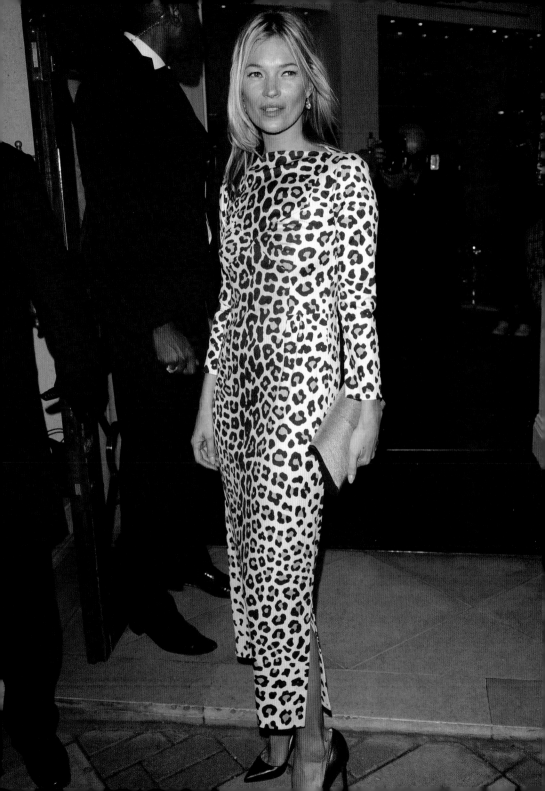

that referenced leopard-print icon Mrs. Robinson, as well as presenting a guest appearance on the catwalk from former Catwoman Julie Newmar.

A photograph of Azzedine Alaïa's legendary 1991 knit leopard-print collection presented a dozen drop-dead-devastating models. They wore leopard print from head to toe: sweaters, leggings, dresses, shoes, berets, even a knit leopard corselette. Once this image was out there, the pattern could not be denied. The impact of all that beauty in one place was simply shattering. The idea so often espoused in fashion magazines, that leopard print had to be used minimally to be in good taste, was under attack.

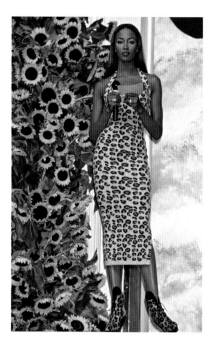

Naomi Campbell takes the stage in a classic Azzedine Alaïa leopard knit dress.

Several solo images from the line feature Naomi Campbell in a leopard dress with leopard accessories against a leopard background—an emphatic middle finger to the idea that leopard print is best in small doses. Campbell had met Alaïa as a teenager in Paris, and he immediately cooked her dinner and gave her a dress. They became good friends on sight, and she often stayed with him when working in the city, watching films from Alaïa's native Tunisia. Their friendship had bilingual fringe benefits: he improved his English, and she improved her French. As one of the first designers to put Campbell on the runway, he worked to boost her career. It's no surprise that he also made her the face of the campaign for his landmark collection.

To this day, Campbell continues to wear the print frequently, and, like many people, she has made it one of her signature looks; unlike many, she is a world-famous supermodel who can alter fashion trends. Part of the print's popularity today is clearly due to her.

The pattern emerged as a signature print for several fashion companies in the late-twentieth century without losing any of its distinction.

Italian luxury fashion house Dolce & Gabbana, founded in 1985, pounced on the print and used it to blast their way to fame. Roberto Cavalli, who invented a procedure used to print on leather often used on North Beach Leather's status leopard-print lambskin dresses, had been around much longer, but he used the print in light and refreshing ways in his relaunched high-fashion resort wear. Gucci implemented leopard print as an "authentic expression" of their fashion house. Versace fearlessly combined bright colors, mixed patterns, and extra flair in their vivid designs. Even staid Coach used jaguar and leopard print on their bags. And the supermodels wore it all.

Moschino Cheap and Chic used the pattern in a way that echoed Patrick Kelly's elegantly wearable designs, but with an added rock 'n' roll flair that included tight jackets and short, tight skirts. This look, far from the catwalk, was a favorite on the 1990s television show *The Nanny*. Created by and starring Fran Drescher, *The Nanny*'s Fran Fine wore a lot of leopard print. Her character was a lovable, uninhibited, rags-to-riches fashion maven, shown in the opening credits in a super-fitted red suit with cheetah-spotted trim, wearing "red when everybody else is wearing tan." Her loud voice and loud clothing were her trademarks, and both garnered passionate fans. She made high fashion seem attainable. She was always almost, but not quite, tacky. She wore leopard print as a signature to the point of overload; memorable moments include wearing a leopard suit and headband while sipping from a leopard-print cup, and getting a matching leopard-print outfit for herself and one of the wealthy little girls under her nannyship. The scene evokes just a touch of the golden Cadillac advertisement from the 1950s, but Fran, though a Cinderella story, remains very much her own woman—and, like a good mother, gains the enduring affection of her charges.

The vision of the perfect stay-at-home mom of the 1950s sitcom was defaced by the character Peggy Bundy, played by Katey Sagal, on the 1990s television show *Married with Children*, who wore leopard print regularly while refusing to get a job, hounding her unwilling husband for sex, and neglecting her children. This time the trope was played for laughs, with an implied mockery of anyone who viewed women with a

throwback attitude, wearing big fluffy hair in a time when chic meant sleek. Her style, while horrifying to some, made a lasting impression. Peggy remains a popular Halloween costume: all it takes is a big red wig, a tight shirt, and a pair of leopard leggings to instantly identify her.

Rock 'n' roll struck fashion again in the late 1990s and early 2000s when post-punk subcultures produced a significant wave of mid-century revivalism that helped to create an independent industry for vintage-inspired and reproduction clothing that's still going strong twenty years later.

The retro subculture at the turn of the twenty-first century reclaimed the Atomic Age aesthetic for their time. Many of them punk rockers, they had originally eschewed the tastes of the adults they held responsible for some of the United States' worst political decisions. However, they were content to co-opt it once they felt free of the authority and moral-purity claims of a generation some perceived as hypocritical.

As the century progressed, everything began to be both in and out of style at the same time. The retro subculture created their own aesthetic out of the aesthetics of previous generations. They combined swing, tiki, exotica, lounge, rock 'n' roll, glam, and punk all into something new that many observers mistook for a drive to re-create the past. As always, music was key to the feel of the scene. Capitol Records released their Ultra-Lounge series featuring lounge music, television and movie themes, and full versions of music that most recognized only from snippets in commercials. Rhino Records released collections of long-lost rock 'n' roll and rockabilly, and even a remastered version of 1930s burlesque star Ann Corio's 1962 album *How to Strip for Your Husband*. This music, which had often been dismissed by their generation as dull or shallow, was reexamined and was given its full due.

The burlesque revival of the 1990s to the 2000s that accompanied this wave of retro was partly a response to the experiences of women in the 1970s and 1980s. While women had only recently won the right to protest sexual harassment in the workplace, to press assault charges even against their husbands, to have their own bank accounts and lines of credit many men—and women who were still concerned about their

status as it related to their men—felt threatened. Women who had come from particularly macho scenes, such as the West Coast hair band culture of the 1980s, were ready to be their own rock stars after experiencing a world where, if they didn't play instruments (and sometimes even if they did), they were treated as completely disposable. They knew they weren't.

Women who were fans of vintage adult ephemera found old film shorts and old men's magazines and resurrected the glamour of burlesque's forgotten stars, particularly those such as Tempest Storm and Blaze Starr, who had an untamed look about them. They created their own versions of variety and strip shows updated for the tempo and attention span of the MTV generation, with a contemporary sense of irony and a sincere sense of affection. They believed that the art form had been underappreciated and wanted to elevate its practitioners, if not strictly re-create the conditions under which they lived.

Peg Bundy (played by Katey Sagal), the 1990s anti-role-model matriarch of television's *Married with Children*, parties with male strippers on a girls' night out.

The pattern emerged as a signature print for several fashion companies.

Bettie Page, who modeled in the 1950s for low-budget camera clubs, fetish photographers, and men's magazine photographers such as Bunny Yeager, became the foremost icon of the retro subculture. Her charisma and evident joy at being photographed leaped from every image. She appeared frequently in leopard-print costumes and bikinis she had made herself, and it was often considered her signature print. Her wavy black hair with distinctive sculpted short bangs was adopted by her female retro fans, and the obvious homage reflected an admiration and respect for a men's magazine model that some outsiders would have expected to be unlikely coming from women. Many women of the retro scene strove to create a space where the cultural contributions made by women in fetish and other adult magazines would be appreciated, and where they were treated like stars instead of social outcasts. Whereas so many nude models remain anonymous and as ephemeral as the paper on which their images are printed, she was both humanized and idolized. And partly due to her influence, leopard print was the scene's signature color.

This wasn't the first time retro had become current. The modern fashions of the 1920s referenced ancient styles. The 1967 movie *Bonnie and Clyde*, starring Faye Dunaway and Warren Beatty as impossibly attractive bank robbers, ignited a taste for 1930s-inspired silhouettes in mainstream fashion. In the 1980s, styles of the 1940s had influenced the shape of the big-shouldered power suit, while the Weimar fashion of the 1920s, surrealistic fashion of the 1930s, and pop art of the 1960s influenced 1980s fashion. Fashion has always mined previous eras for inspiration, but now it was engaging several eras at once, and much more consciously, as so many old magazines and movies became easily available to help aficionados selectively curate the past. They could admire the

beauty of past artists' and designers' aesthetic accomplishments, even when they didn't want to live in those times.

The 1950s, 1960s, and 1970s, eras most often associated with 1990s retro, were all the rage in the 1980s, but the nostalgia was for a different aspect of the eras than in the 1990s. The movies *American Graffiti* and *Grease* as well as the television show *Happy Days* reflected a wave of nostalgia for a post-war America before the conflicts and unpleasant political awakenings of the civil rights protests through Watergate. The 1950s to early 1960s were partly reimagined as the post-war happy family consumer culture that had been marketed at the time, and much of it was filtered through a comically simplified version of greasers and gangs, like the affable Fonzie. Sha Na Na, a hugely successful band that styled itself on street musicians, particularly doo-wop groups, and the music of rock 'n' roll's first incarnation, had made their first appearance at the historic Woodstock in 1967 and were a huge hit there. The 1970s wave of 1950s nostalgia was devoted more to providing entertainment rather than influencing fashion and lifestyle, and it was an idealized, wistful recollection of an unrealized American dream, evoked by the very name *Happy Days*, before the assassinations of the Kennedy brothers and Martin Luther King Jr. It was an attempt to return to a manufactured sense of purity.

The retro movement of the late 1990s, which had gone through the gritty streets of punk and come out in the velvety lobbies of lounge, had an interest in the underbelly of the 1940s–1960s, the adult-entertainment side, the nightlife side. If the 1970s retro fad was set in the suburbs, the 1990s retro culture was set in the city. Poison Ivy, the sneering dominatrix-styled guitarist for the Cramps, was the subversive perfect pinup for this new wave. In the 1980s, a taste for fetish sex or being queer or a sex worker was categorized (often on a legal basis) as deviant, undesirable behavior; the retro revival sought out and welcomed all these deviants. With the World Wide Web and standardized Internet access, passionate aficionados were able to connect through the Internet for the first time, and they began to establish their own conventions. Many of them re-created the glamour of old Vegas. People reinvented themselves

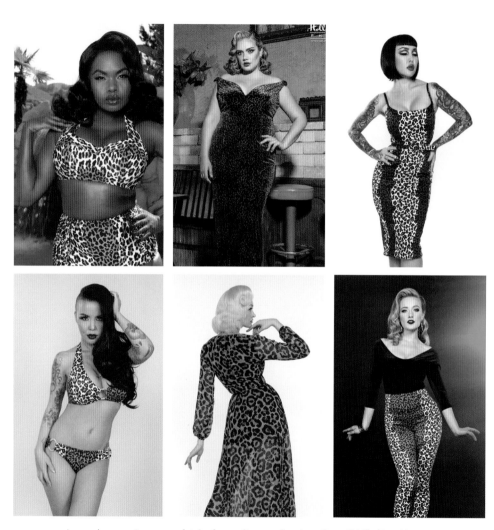

Leopard appears in a range of styles from online retro boutique Pinup Girl Clothing. Many retro boutiques, including What Katie Did, Modcloth, and more, produce items in limited quantities and rely on direct online sales.

as crooners and showgirls, giving themselves permission to dress up as if they'd been hired to do so. They didn't need to be invited to the red carpet; they rolled it out for themselves, inventing huge weekend-long events such as Tease-O-Rama, Viva Las Vegas, and the New York Burlesque Festival.

Burlesque fans also made a yearly pilgrimage to a mecca in the desert outside of Helendale, California, a burlesque reunion and pageant held on a ranch that featured a stage, a pool, and a burlesque museum called Exotic World. It was founded by a 1950s burlesque stripper and activist named Jennie Lee, then inherited and managed by one of her peers and close friends, Dixie Evans, in 1990. Burlesque legends Tempest Storm, Kitten Natividad, and Tura Satana attended and often performed, while new legends-in-the-making such as Indigo Blue, Desiree D'Amour, and Tigger came to learn from them how to handle giant feather fans and twirl tassels, and to compete for the title of Miss Exotic World.

Dita Von Teese, a former strip joint stripper, fetish adult film actress, and *Playboy* model, became the biggest star of the burlesque revival. Whereas burlesque in its heyday had been a highly paid field, at least for its stars, neo-burlesque was very much a do-it-yourself endeavor. It also generally paid less than strip club stripping, so Von Teese used her strip club and modeling earnings to develop lavish costumes and props with her artistic partner (also a strip joint feature dancer and burlesque artist) Catherine D'Lish. Dita's exquisite and playful fashion sense put her in high demand at celebrity events and fashion shows.

Her style managed dichotomies as efficiently as burlesque has historically done. Burlesque is said to mock the high brow and celebrate the low brow, and fashion easily does the same. She combined the supposedly out-of-date pinup aesthetic of big panties (otherwise intolerable in the 1990s, when high-hip thongs and string bikini panties were the chicest underwear peddled by Victoria's Secret) and bullet bras, garter belts and stockings, and Bettie Page-styled hair with a modern public shamelessness about her strip joint past and her playful attitude toward kinky photo shoots and fashion. She could be in a simple leopard-print leotard with Halloween-store cat ears and tail, and combine it with flawlessly

Left: Twenty-first-century burlesque producer and performer Calamity Chang shows off a custom-made red sequined leopard ensemble photographed by Ramonsss.

Right: Dirty Martini, international burlesque star, posing in 1960s Vanity Fair on Fire Island for photographer Steven Love Menendez in 2017.

applied makeup and super-sleek hair to make it look expensive, and she looked stylish in fetish clothing or vintage acquisitions, which she often had altered and perfectly fitted to her lithe frame. She was the supermodel of burlesque.

Companies such as Daddy-Os and Stop Staring! began making clothing that looked vintage but wasn't. They combined the best silhouettes of the 1940s–1960s with modern fabrics, especially stretch fabric in the women's clothing, which allowed for simpler construction techniques. While many revivalists were only interested in true vintage, others couldn't wait to find the perfect New Look dress, lamé pantsuit, or leopard pencil skirt and were thrilled to buy them new.

Retro wear grew in popularity throughout the twenty-first century, with designers and manufacturers thriving. Pinup Girl Clothing, a brand

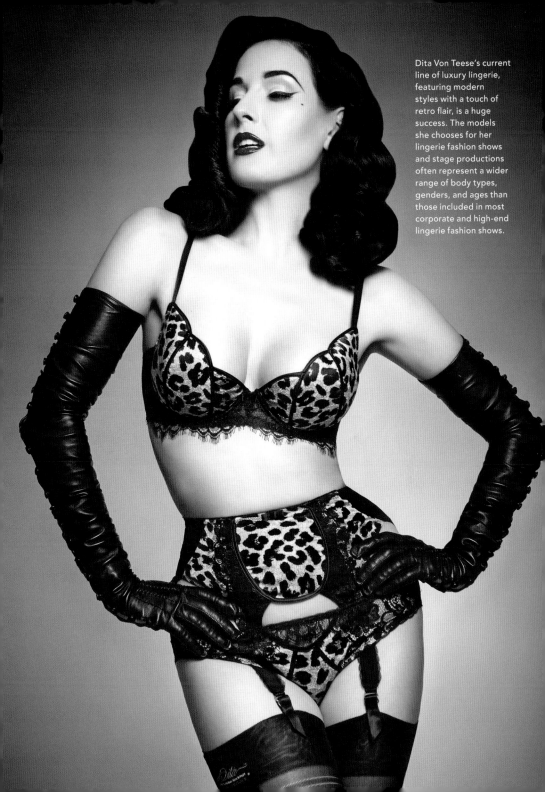

Dita Von Teese's current line of luxury lingerie, featuring modern styles with a touch of retro flair, is a huge success. The models she chooses for her lingerie fashion shows and stage productions often represent a wider range of body types, genders, and ages than those included in most corporate and high-end lingerie fashion shows.

Fierceness became admired as both a personal and professional attribute.

created by Laura Byrnes in the 1990s as a source of custom gowns for strippers, grew into an online empire servicing the rockabilly, retro, and neo-pinup communities. Laura designed perfect modern clothing with retro flair and employed more designers, including collaborations with models Micheline Pitt and Masuimi Max, former porn star Traci Lords, and Mistress of the Dark, Elvira. Her business continues to grow based on exclusive designs with a distinctive aesthetic, presented by diverse models, marketed to a thriving niche.

The independent woman marketing to other independent women became a powerful force in the twenty-first century, and increasingly, fierceness became admired as both a personal and professional attribute. However, the mainstream fashion press often overlooked these independent clothing designers and companies, while still proceeding in fashion cycles that attempted to reject the cycle just before it. After the high glamour of the late 1980s and early 1990s, fashion magazines embraced grunge, a kind of anti-glamour that fostered the much-lamented heroin chic (waifish, somewhat dazed-looking models in overly comfy and often tattered clothing). That look grew out of the music scene in Seattle and influenced music fashion into the middle and later part of the decade. Hair bands were mocked and spandex pants were out; and anti-fashion did what it so often does, which is to come into fashion. Kurt Cobain, famous for his flannels, posed in a leopard-print coat in his last shoot, with photographer Jesse Frohman. Grunge's own supermodel, Kate Moss, was and is a dedicated wearer of leopard and a star who still rules. All in all, whether you were a supermodel, a nanny from Jersey, a bad mom, a good mom, an heiress at a resort, or a stripper looking for the perfect moneymaking outfit, the turn of the twenty-first century was a good time to be a leopard-print lover.

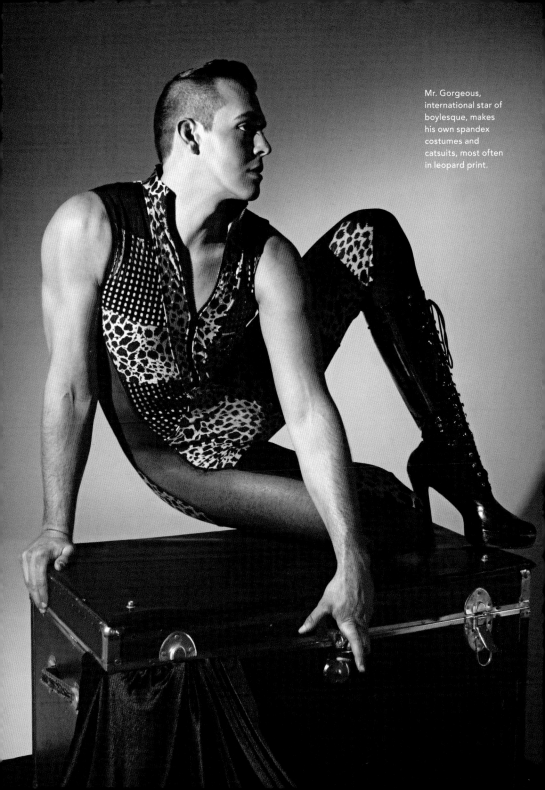

Mr. Gorgeous, international star of boylesque, makes his own spandex costumes and catsuits, most often in leopard print.

A BRIEF HISTORY OF VINTAGE CLOTHING

It might seem odd to think of the practice of wearing vintage clothing as having a history, but it is a uniquely twentieth- and twenty-first-century practice. Wearing other people's old clothes used to be considered, well, tacky. Most clothing dealers and collectors today would distinguish between secondhand clothing, which is just clothing someone else has owned; vintage clothing, which could be many things but is, generally speaking, clothing that is more than twenty years old; and antique clothing, which is more than one hundred years old.

In earlier centuries, the only clothing passed on was ceremonial, such as royal robes or wedding gowns to the royal and other well-to-do, or secondhand, to the poor or to the very young. It had little to do with style. New clothing could make reference to the past, but no one actually wanted to wear the clothing of the past.

Prior to the 1920s, most vintage clothing wouldn't have been very wearable for the active women of the era. Almost no one wanted to go back to hoop skirts or hobble skirts, and modern lifestyles, which included driving cars and using escalators, made long Victorian skirts impractical. In the decades following the 1920s, the idea of wearing vintage clothing wouldn't have been appealing as fashion, as the Great Depression of the 1930s and the war rationing of the 1940s made new clothing hard to come by and therefore much more desirable.

Vintage clothing developed élan in the second half of the twentieth century in great part because of its relative uniqueness in the face of increased mass-manufacturing. It offered individuality and a sense of historic connection. Often the fibers were of higher quality than contemporary synthetics.

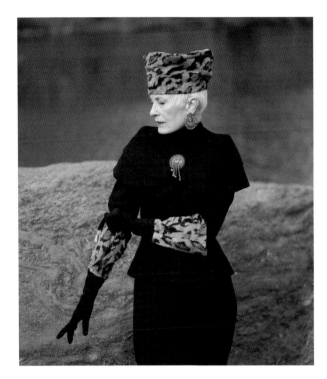

Judith Boyd created the vintage fashion blog Style Crone and is a participant in Ari Seth Cohen's Advanced Style project. She's a devoted collector of hats and leopard print.

Hippies and flower children of the late 1960s Woodstock era loved to wear flowing and beaded clothing, in whatever condition, from the Edwardian era through the 1920s. Some of the first successful vintage clothing stores—not thrift or secondhand stores, but true vintage stores that curated for high quality and style—sprung up in the Haight-Ashbury section of San Francisco during this time. Later, glam rockers loved vintage costumes and scarves and feather boas. Vintage and damaged clothing became popular among punks in the 1970s because the idea of wearing someone else's old clothing was countercultural to the consumerist imperative of capitalism.

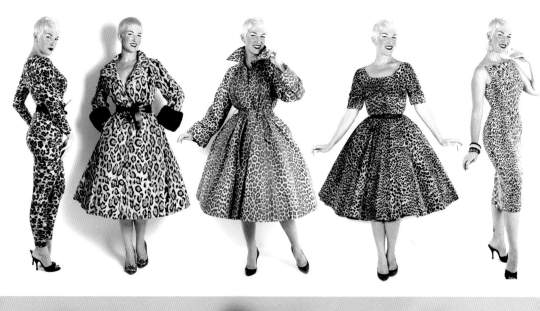
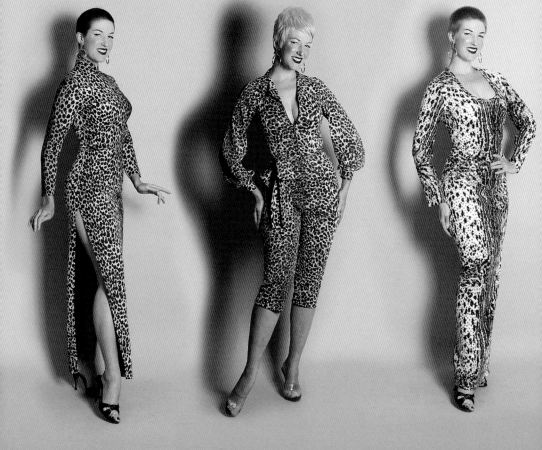

The motivation to wear vintage clothing in the 1980s was enhanced by similar desires for individualism and counterculturalism in the face of suburban shopping malls that produced literally acres of similar clothing. Vintage was the gourmet home-cooked meal to the mall's food court. Since malls had taken over, and conformity was prized in the suburbs, buying vintage clothing allowed nonconformists to deliberately stand out. Needless to say, it didn't take long for nonconformity itself to hit the malls, once it became popular enough to be profitable; knockoffs of street style, rock 'n' roll fashion, and punk clothing began to infiltrate the malls and the co-option peaked with the opening of Hot Topic, a clothing store devoted to goth style and band T-shirts, in 2000.

The revivalists of the 1990s included a subset of devoted vintage enthusiasts, which included subsets of aficionados of different eras. There were the 1920s enthusiasts, who mastered the Charleston (it's not that easy, try it) and drank absinthe and gin; the 1940s enthusiasts, who entered or watched swing dance competitions and spent hours learning how to do victory rolls and pompadours; the 1950s enthusiasts, some of whom were also fetishists; and the 1960s enthusiasts, who were often fans of extreme false eyelashes, French go-go music, and Russ Meyer's films. A few prized the 1970s, with a serious eye for the perfectly outrageous, including the loudest leopard print and the highest platforms.

The Internet has made it easier to find every kind of vintage fashion, including reproduction vintage, but the hunt for ideal leopard print is still heated. Vintage dealers have devoted followers on Instagram, and some of them will hold the best leopard-print pieces aside for their special clients. No matter how available leopard print is, it always manages to feel remarkable and rare, and a quality vintage piece is a coveted find.

Opposite page: A veritable catalog of fine vintage leopard-print pieces shows some of the best fashions from the 1950s and 1960s, photographed to sell from Butch Wax Vintage. Amanda Suter is the curator, model, photographer, web manager, salesperson, and sole proprietor of the company.

SPOTTED EVERYWHERE

HOLD ON TO YOUR LEOPARD
[PRINT] FOR DEAR LIFE. YOUR FUTURE
OUTFITS DEPEND ON IT.

—whowhatwear.com

After the Y2K bug was squashed in 2000, computers became more and more prevalent, leading to the rise of the now ubiquitous global presence of the Internet. Consumers could access the World Wide Web first at home and then, as evolving technology produced smartphones, everywhere else. Consumers could carry the Internet on devices slim enough to fit in their pockets, which made it easier not only to shop online but also to locate exactly what they wanted . . . and what they wanted frequently included lots of leopard print.

Online shopping, a digital descendant of the paper catalogs that brought fashion to frontier towns in the nineteenth century, began to offer a wider selection of goods to areas with fewer retail options. Every fashion trend in every price range was suddenly at everyone's fingertips. This convenience led to the decline of brick-and-mortar retail. The resplendent shopping malls of the 1980s were abandoned as big department stores lost their followings, flagship stores from major clothing chains closed, and big brands were forced to evolve or fail as their sales models became outdated. As the first two decades of the 2000s continued, shoppers easily found independent designers and were able to

connect with vintage clothing dealers worldwide, and even buy directly from wholesalers, all without ever having to leave their homes. While challenging for traditionalists, it was a brave new world for modern shoppers (and entrepreneurs).

Where fashion retail went, so, too, went the fashion journalist. In a trend that had been growing since the youthquake of the 1960s, the newest fashion was increasingly inspired by street style rather than high society, and the "streets" were now online, with people posting photographs of themselves or friends showing off the latest styles on social media. As a result of this democratization of fashion, it became more difficult for traditional magazines to enforce trends, which were cycling more quickly than ever, their pace accelerated by an ever-growing number of independent online fashion journalists, bloggers, and social media influencers. Print fashion journalism raced to keep up with the influencers, often covering their online activity in glossy analog magazine pages. It struggled to maintain its status as a forecaster of fashion, increasingly becoming a reporter of the more immediate sources of information that fulfilled smartphone owners' needs for fast, fresh, friendly news that related to their personal wardrobe preferences.

Moving at the speed of Wi-Fi, fashion reached a point where everything was in vogue at the same time, aptly demonstrated in a 2015 special issue of *People Style Watch* entitled "Style Twins Then & Now," which paired clothing trends from decades past with contemporary celebrities in similar dress. It could be said that the idea of something being definitively in or out of fashion has itself gone out of fashion; the range of options of the entire twentieth century persisted into the twenty-first, and leopard print led the pack.

More and more, people wore it however the hell they liked: it became the print of choice for people with choices, and more people had more choices than ever before. Indeed, to some extent, leopard print proudly and loudly represents the *ability* to choose what to wear. Its popularity was global and showed up on everything from saris and kimonos to hajibs, and everything else in between.

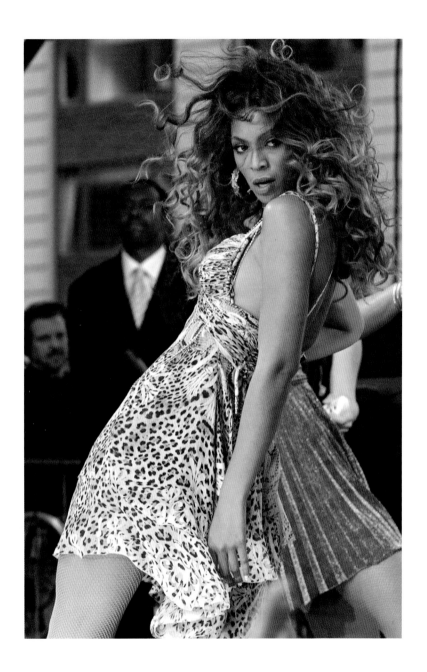

The era also saw the rise of a staple of online reporting: rapid-fire delivery of news or information in a form that could be quickly read and easily shared. So, to close out this exploration of leopard print at the dawn of the new millennium, here's the most popular informational format of the time: the leopard listicle.

Twelve Fierce Places to Spot Leopard Print in the Early Twenty-First Century

1 ON THOSE WITH KILLER STYLE

Buffy slayed vampires in it, while Beyoncé simply slayed.

2 ON THE RED CARPET

Flaunted by everyone from Helen Mirren, who paired a leopard-print flowing gown, recalling Dior's classical influences, with a Ramones-style leather motorcycle jacket, to Jaden Smith, who wore leopard-print drop-crotch pants à la MC Hammer's signature 1980s dancewear.

3 ON ALL AGES

Children embraced it on everything from baby onesies to Lisa Frank pajamas. In their groundbreaking January 2017 issue on gender, *National Geographic* featured a nine-year-old trans girl wearing leopard-print leggings. Mature women embraced it, too: *Loose Woman* poet Sandra Cisneros celebrated her fifty-fifth birthday with a benefit for her literary nonprofit to which everyone wore the print, including her pet Chihuahua.

4 ON MOTHERS-TO-BE

Pregnant women stood out in it, like Eva Mendes, who wore a sweet leopard-print tent dress to the sixtieth Cannes Film Festival.

5 IN SILHOUETTE

The dress shapes that had reemerged in retro fashion in the 1990s re-reemerged in mainstream fashion, as body-conscious sheaths and natural shoulder lines were contemporized in the print.

Opposite page: Beyoncé owns the stage in an exuberant pose during a 2006 performance in Times Square, exhibiting the fresh and lighthearted side of the print.

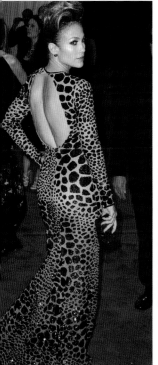

Twenty-first century goddesses evoke the power of the print, whether speaking at the White House, owning the red carpet, or battling aliens. *Top:* Betsey Johnson, Chrissy Teigen, Michelle Obama, and Janet Mock. *Bottom:* Nicki Minaj, Buffy the Vampire Slayer (Sarah Michelle Gellar), Jennifer Lopez, Anna Wintour (with Sienna Miller), and Gwen Stefani.

6 IN FITNESS

Biker shorts and leotards popular during the 1980s aerobics craze gave way to sports bras, yoga pants, and flowing cardigans, all fabulous in big-cat prints.

7 ON ALL SHAPES AND SIZES

Plus-size fashion gained mainstream visibility, with curvy supermodel Ashley Graham creating her own line of lingerie featuring lots of leopard. She also appeared in a lip-sync battle in which she paid tribute to Shania Twain's full leopard regalia from the musician's 1997 "That Don't Impress Me Much" video, and was featured on the cover of the Fall Fashion issue of *New York* magazine in leopard print from head to toe. Body diversity in modeling became an increasing concern in fashion marketing, often influenced by the ability of social media users to publicly express their opinions and preferences directly to both independent and corporate brands.

8 ON THE CATWALK (AND OFF)

Leopard print stormed runways and fashion shows. The high-end luxury animal print captivated virtually every designer at one point or another, each season showcasing another glamorous leopard-print line. Both *Vogue* editor Anna Wintour and enduring supermodel Kate Moss showed up in fashion's front rows wearing leopard coat after leopard coat. Fashion expert André Leon Talley preferred a leopard caftan instead.

9 IN MUSEUMS

New York's Metropolitan Museum of Art celebrated the contributions of animals to fashion in a 2005 exhibit called *Fashion Untamed*. While the show featured many different animals, the big cats, needless to say, played a significant part. In other museums, various exhibits of designer Jean Paul Gaultier's work showed both his leopard costume worn by Chris Tucker in *The Fifth Element*, and a dress covered by an authentic-looking leopard pelt that, upon closer examination, proved to be entirely beaded. The Museum at FIT displayed leopard-print items by Rudi Gernreich, James Galanos, and more in their 2017 *Force of Nature* exhibit.

10 ON FIRST LADIES

Michelle Obama wore it in the White House, and other first ladies spotted in the print include Nancy Reagan, Hillary Clinton, and Laura Bush. The fur is gone but the print lives on.

11 AROUND THE WORLD

The New Yorker's May 4, 2017, article "The Meaning of Leopard Print" reviewed "From Mobutu to Beyoncé," an exhibition by photographer Emilie Regnier, who traveled the world to capture people wearing leopard print in Africa, Europe, and North America, including a man who had leopard spots tattooed all over his body. The print has been incorporated into various modern fashions of India, the Middle East, Asia, Africa, and many other regions, including Australia, where there are no native spotted cats. And it has been updated even in traditional use: Zulu Chief Theresa Kachindamoto wore faux leopard fur in place of the traditional genuine pelts to help protect the endangered species as she demanded better treatment for women and girls, eliminating child marriage from her constituency in Malawi.

12 BEYOND

With leopard print more affordable and available than ever before, and always in style, it's no wonder that, in the digital age, it couldn't be easier to spot the big cat. From fearless fashion diva Lady Gaga, prowling the red carpet in carefully crafted, one-of-a-kind ensembles, to the casual shopper buying a leopard-print scarf at a thrift store, everyone can finally get their paws on this coveted pattern.

YOUR PERSONAL LEOPARD PRINT

Leopard print has been applied to fabric in dozens of ways over the centuries. It has been woven and dyed into it; painted, block-printed, and dyed onto it; embroidered upon it; screen-printed; machine-roller-printed; ironed on; and now, with digital printing, applied with inkjet printers or dye sublimation in both mass-manufactured and one-of-a-kind textiles.

Custom-printed fabric isn't new; after all, for thousands of years almost all clothing, with the exception of uniforms, was custom-made, since most civilians did the clothes making. Even after mass-manufacturing became the norm in the twentieth century, however, custom techniques, such as artisan silk-screening and iron-on, continued to be popular among subcultures and craftspeople. However, the twenty-first century's proliferation of custom services is ground-breaking. Today, just about anyone with an idea and a cell phone can customize their own clothing. Services can print any image onto clothing, sneakers, hats, and more. Furthermore, users can upload their images and have them printed as an all-over design on silk, cotton, linen, fleece, and stretch fabrics; buy it by the yard; and make their own dresses, shirts, tote bags, and yoga pants. You can photograph a leopard at the zoo, or you can draw your own leopard, and use those images to design and wear clothing no one else has. Just make sure your uploaded design doesn't belong to someone else—copyright laws apply to any image, including those on fabric. Now, go make something fierce.

#LEOPARDPRINT

NOT LEOPARD? NOT INTERESTED.

—Leandra Medine

Started as a blog by Leandra Medine, Man Repeller, "a humorous website for serious fashion," is now a full-fledged company, with related ancillary products and social media feeds. As of summer 2017, Man Repeller had attracted almost two million followers on Instagram by ignoring society's predilection for telling women to be concerned with what men do or do not want them to wear, and instead by encouraging them to dress for their own enjoyment, saying, "Good fashion is about pleasing women, not men." This concept of self-pleasure through dress is obviously not as repellent as the name of the company might have us believe—founder Leandra Medine married just a couple years after starting the company. Medine writes regularly about her fashion passions, one of which is leopard. She describes giving up the print at one point, then giving up giving it up. She's now committed.

Medine is a perfect example of an influencer, someone whose web presence can impact millions of readers. Many of them share their love of the print in a public forum, in photos and in words, more often than not accompanying their appreciation with #leopardprint. When they hashtag the phrase, people not only illustrate its contemporary meaning but also redefine that meaning. For instance, it's no longer exclusively feminized or sexualized. People of every gender wear leopard now, and so do their babies (though women remain the leaders in leopard). The more

accessible fashion becomes, the more an aspect of everyday life, the more leopard print ascends to the apex of the fashion pyramid. When people want it, they can get it, and when they can get it, they want it. An intrepid tracker need only enter #leopardprint into any search engine and their device will be flooded with the latest in lingerie, clothes, coats, shoes, nails, lip tattoos, furnishings, kitchen appliances, cakes, cars, air fresheners, dog collars, hats for cats, and more—all in leopard print.

Every year, more magazine articles about clothing trends boldly declare that leopard is back, though it doesn't take an eagle eye to see that it never went away. From the goddess to the queen, the bathing beauty to the movie star, Dior to Cassini, the bad mother to the punk, the rock

Leandra Medine at Kate Spade's Leopard-LeopardLeopard event in New York City, 2017.

The babies of most big cats, including lions and pumas, are born with spots. On a primal level, we know these cubs, and we see their playfulness and mischief in the print.

star to the supermodel, the vintage aficionados to the red-carpet diva—indeed, from flappers to rappers—leopard print has always been a part of the cultural milieu.

Many of today's hottest celebrities continue to rock the print. Does the ready availability of leopard print mean that it is losing its fierceness through familiarity? Hardly. The human pupil often still dilates at the sight of it, a primal reaction we can't control. The passion for the print is evident not only in its champions—like sports legend Serena Williams who, when her self-designed hot pink leopard tennis dress caused a stir on the courts, simply declared, "I just love leopard print"—but also in its detractors, many of whom feel strongly enough to fill an entire Reddit thread with their complaints about the pattern. This sort of passion, this visceral reaction, the sheer number of people who append their posts and pictures with #leopardprint, show that its impact remains undiminished.

How much leopard print is too much? In this author's opinion, there's no such thing. Search "Leopard-Print Coffin" and, in addition to eco-friendly decorated receptacles for the deceased, you'll find a picture of a spotted casket being pulled through the streets of Cardiff in a horse-drawn carriage. That might seem over the top, until you read the story that goes with it. The woman in that coffin was known for her passion for the print, and she died pushing her two daughters out of the way of a hit-and-run driver, saving their lives at the cost of her own. Now that's fierce.

A 2016 commercial for Magnum Ice Cream Bars titled "Release the Beast" shows several women flaunting their strength in environments, ranging from a rooftop bar to a corporate office, each with a dangerous animal as her companion. Underscored by Jack White's edgy rock guitar, one vignette features a woman in a leopard-print blouse taking command of a meeting, clearly the boss of the room, with a leopard beside her. A woman of power with a leopard by her side, pitched as fiercely contemporary, is an image of strength so ingrained in the collective unconscious that it harkens back to prehistory, and the *Seated Woman of Çatalhöyük*.

We put on clothing to help us face the day, and the night, as the people we need to be. So ignore the articles that tell you that leopard is in or out of style, tacky or elegant, whether it should be worn in the office, to a wedding, or the prom. Leopard print has signified luxury, freedom, rebellion, exoticism, naughtiness, haute couture, the beach, the bedroom, being the best, being the worst, being tacky, being strong, being contemporary, being vintage, being super, and being divine. It still means all those things, and more—as defined by whomever is inhabiting it. So wear it how, and where, and when you want. Boldly show the spots that celebrate the beauty, strength, power, adaptability, playfulness, and ferocity of the leopard herself.

As long as wearing the print continues to give its fans this much pleasure, it's not going anywhere, and the people wearing it are going everywhere.

This fabulous gown was worn by Kendall Jenner in Magnum Ice Cream's "Release the Beast" campaign. Designed by burlesque star and designer Catherine D'Lish, it features yard after yard of fierce, frothy mesh.

WHAT NOT TO WEAR

Purchasing a genuine leopard fur coat, or anything made from a leopard or other great cat, is, generally speaking, prohibited by law. And thank goodness for that—many of these animals are endangered, which means if we start wearing them again, we'll lose them altogether. Coats made from exotic animal pelts continued to sell legally up through the 1960s, despite warnings that their populations were declining. However, several regions, including several states in the United States, began to enact their own regulations against importing and selling furs across their borders. The Endangered Species Act of 1969 protected some animals, but more specific laws were needed to effectively prohibit trade in their skins. In 1970, New York state passed the Mason Law, which prohibited trade in cheetah, clouded leopard, jaguar, leopard, margay, ocelot, and tiger skins, and the Endangered Species Act of 1973 prohibited trade of even more species. The Convention on International Trade in Endangered Species of Wild Fauna and Flora, commonly called CITES, is the result of a resolution adopted a decade before by members of the International Union for the Conservation of Nature (IUCN). The Convention was signed in 1973 by dozens of governments, and went into international effect in 1975, when trading fur became effectively illegal.

These laws can change according the animals' fluctuating degrees of endangerment. Most are fluctuating in the direction of greater vulnerability, and animals are more likely to be added than subtracted from this list of illegal pelts. There are some permits individuals, organizations, and businesses can apply for that make exceptions to some of these regulations, but they are exceptions, not the law.

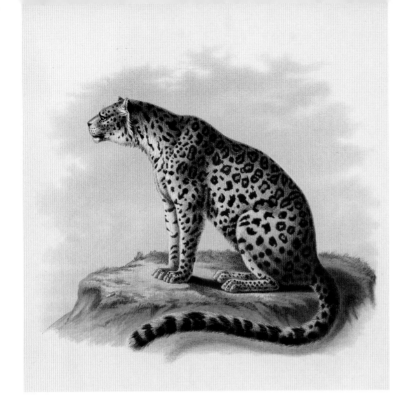

Not only are new exotic fur items illegal for trade, but for the most part vintage coats, or other items made from their fur, are regulated as well. Regulations can vary at borders; in the United States they can be monitored by both U.S. Customs and Border Protections and the World Wildlife Federation. Generally, however, selling or buying a vintage leopard fur coat can result in up to five years in prison and a $250,000 fine for an individual, and double that for a business.

Items that are seized in the United States can end up in the U.S. National Wildlife Repository Warehouse in the Rocky Mountain Arsenal National Wildlife Refuge in Colorado, where those concerned about the animals can pay their respects and reinforce their resolve to help support and preserve these species and their habitats.

It's more important than ever to protect these unique animals from the fur industry, as their habitats are being diminished by both nature and man. It benefits them to resist any urge to wear their fur, recent or vintage, in order to be supporters of their well-being.

Keep the World Fierce

Leopards and their kin are powerful survivors; their greatest threat is man.

Getting to know the great cats while researching this book was inspiring. Learning how endangered so many of them are has been shocking.

The Amur leopard is critically endangered. The population of wild cheetahs has been estimated to be as low as seven thousand. The population of wild Siberian tigers has been estimated to be as low as 480 (it was once as low as forty).

Conservationist Dereck Joubert, whose stunning book *Eye of the Leopard* will make you love these cats more than you ever thought you could, says that he was originally appalled by leopard print, knowing what man had done to the cats and their environments. After years of working among the cats, however, he sees the print's popularity as a tribute to these spectacular animals. I hope all the fashion and designs in this book will inspire readers to constantly seek new ways to show our appreciation for these animals with more concrete practices.

Ironically, the very mass-production that gives us so many options in our clothing can cause environmental issues that endanger the animals' habitats. Vintage, secondhand, and ethical sourcing can help, but we are also learning that we need to manage our production and distribution methods. Scientists and manufacturers are working to resolve these issues in the face of complications from consumerism and globalism—and in line with ways that support the lives of the workers who produce the clothing as well, some of whom cannot even afford the clothing they make. We who love to wear this pattern can help keep the leopards alive. Every time you wear the print, think about the leopards who make it possible. If you are inspired by them, here are some of the many organizations you can support, whether by making a donation,

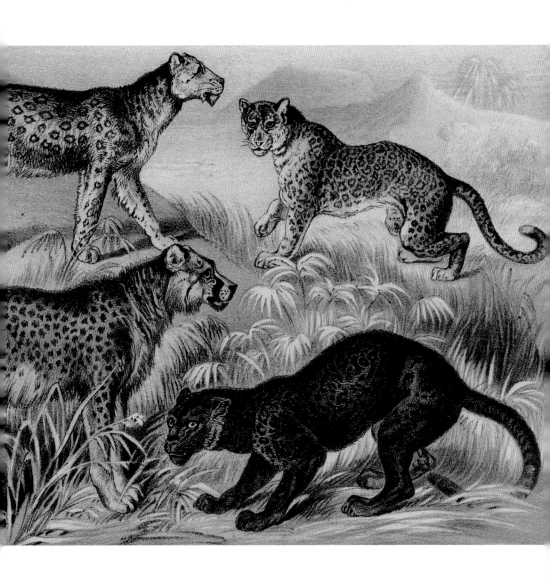

spreading the word about their work, or, if you have the time, volunteering to do work for them. Their work encompasses many species other than wild cats, so be sure to visit their websites and get more information. If we do our best, we can keep the leopards alive to flourish, and to inspire generations to come.

THE INTERNATIONAL UNION FOR CONSERVATION OF NATURE
www.iucn.org

The IUCN is a vast membership of organizations concerned about the environment and the animals that depend on it. It brings together information and resources from across the earth to understand both short-term and long-term solutions, studying intersections of governmental and civil impact to help create solution-based global strategies for protection and growth in the natural world. Options to help include financial donations, sharing expertise and other resources, and promoting initiatives.

PANTHERA
www.panthera.org

There is no other organization like Panthera, formed to help preserve endangered wild cat species. They strategize with international teams of professionals to protect big cats from illegal fur trade and unsustainable trophy hunting practices. They strive to support them in ways that serve their natural environments and other wildlife within them.

BIG CAT RESCUE
www.bigcatrescue.org

Big cats and other animals are often abused in commercial situations where they are displayed for entertainment or bred as pets. The regulations regarding this vary from country to country, and from state to state within the United States. Big Cat Rescue's mission is to help these animals survive and thrive, even when they've been abused to the point of being unable to return to nature, and to end these harmful trades. The organization is accredited by the Global Federation of Sanctuaries. Check out their gorgeous Instagram page and visit their website to get involved.

WILDLIFE CONSERVATION SOCIETY
www.wcs.org

The Wildlife Conservation Society works to raise awareness about environmental issues and to influence legislation that affects them. Their website describes critical conservation issues and provides detailed action plans for supporters to help.

THE FUND FOR ANIMALS
www.fundforanimals.org

The Fund for Animals, an affiliate of the Humane Society, was founded by author Cleveland Amory in 1967. The organization operates the Black Beauty Ranch animal sanctuary in Murchison, Texas; the Wildlife Center in Ramona, California; and the Duchess Sanctuary in Oakland, Oregon, allowing private tours and photography opportunities to promote the well-being of injured and abused wildlife. They have initiated and participated in historic initiatives for animal protection, including anti-fur campaigns in the 1960s that featured leopard-print faux fur as an alternative to wearing the fur of endangered big cats.

BIG CATS INITIATIVE (NATIONAL GEOGRAPHIC)
www.nationalgeographic.org/projects/big-cats-initiative

The Big Cats Initiative, overseen by Beverly and Dereck Joubert, is a team of writers, filmmakers, and conservationists who are working toward long-term preservation of big-cat species. Through diligent observation and documentation, they hope to raise awareness and inspire action to protect the cats and their habitats.

Wildlife photographer Jonathan P. Wightman captured this stunning beauty on camera alone in 2016 at an animal preserve. If we work to provide a better environment for animals (and people, too!), we won't have to look back with regret

Reading List

Every item around us has its own complex and infinite history, and creating a history of leopard print required lots of research to find a direction. While working on this book, I read hundreds of books and articles, in print and online, but mostly at the New York Public Library. I also watched documentaries, news videos, and fashion shows online; visited additional libraries and museum exhibits, especially at the Brooklyn Museum and the Museum at FIT; went to fashion conferences; and talked with fashion scholars, designers, and wearers of leopard print. Several resources were helpful to me while putting this book together:

Albrechtsen, Nicky. *Vintage Fashion Complete: Women's Style in the Twentieth Century.* San Francisco: Chronicle Books, 2014.

Bloomsbury Fashion Central. http://www. bloomsburyfashioncentral.com.

English, Bonnie. *A Cultural History of Fashion in the 20th and 21st Centuries: From Catwalk to Sidewalk.* New York: Bloomsbury Academic, 2013.

Gunn, Tim. *Tim Gunn's Fashion Bible: The Fascinating History of Everything in Your Closet.* New York: Gallery Books, 2012.

Kawamura, Yuniyu. *Fashion-ology: An Introduction to Fashion Studies.* New York: Bloomsbury Academic, 2006.

Lynch, Annette, and Mitchell D. Strauss. *Changing Fashion: A Critical Introduction to Trend Analysis and Meaning.* New York: Berg, 2007.

Ross, Robert. *Clothing: A Global History: Or, The Imperialists' New Clothes.* New York: Polity, 2008.

Steele, Valerie. *The Berg Companion to Fashion.* New York: Berg, 2010.

Vintage Fashion Guild. http://www. vintagefashionguild.org.

"We Wear Culture: The Stories Behind What We Wear." Google Arts & Culture. https://www. google.com/culturalinstitute/beta/project/ fashion.

The following resources were particularly helpful in their respective chapters:

INTRODUCTION

Hoerburger, Rob. "Eartha Kitt, a Seducer of Audiences, Dies at 81." *New York Times*, December 25, 2008. http://www.nytimes. com/2008/12/26/arts/26kitt.html.

Kitt, Eartha. *Confessions of a Sex Kitten.* Fort Lee, NJ: Barricade Books, 1991.

TV One. "Eartha Kitt Said Black Lives Matter in 1968." YouTube video, 1:57. Posted July 14, 2016. https://www.youtube.com/ watch?v=55M2jMGOk-A&t=2s.

WHO WORE IT FIRST?

Clutton-Brock, Juliet. *DK Eyewitness Books: Cat.* New York: DK Children, 2014.

International Union for Conservation of Nature. https://www.iucn.org.

"Leo Fashion Style: Pick Leopard Print." *Star Sign Style.* http://starsignstyle.com/leo-fashion-style-leopard-print-zodiac/.

FIT FOR A GODDESS

The Ascent of Woman. Documentary series. BBC Two. http://www.bbc.co.uk/programmes/b0693dsh.

Berridge, Kate. *Madame Tussaud: A Life in Wax.* New York: Harper Perennial, 2007.

Bolton, Andrew. *Wild: Fashion Untamed.* New York: Metropolitan Museum of Art, 2004.

Chase, Loretta, and Susan Holloway Scott. "On the Cutting Edge: 18th c. Leopard-Patterned Fashion." *Two Nerdy History Girls,* November 13, 2013. https://twonerdyhistorygirls.blogspot.com/2013/11/on-cutting-edge-of-18th-c-leopard.html.

Cooney, Kara. *The Woman Who Would Be King: Hatshepsut's Rise to Power in Ancient Egypt.* London: Oneworld, 2015.

Cotterell, Arthur, and Rachel Storm. *The Ultimate Encyclopedia of Mythology.* Leicester, United Kingdom: Hermes House, 2003.

Hatshepsut. Exhibit at the Metropolitan Museum of Art, New York, April 2017.

Phillips, Charles. *Aztec and Maya: The Complete Illustrated History.* Metro Books, 2016.

Steele, Valerie. "Paris Fashion." Presentation at the Fashion Institute of Technology, New York, October 2017.

A Woman's Afterlife: Gender Transformation in Ancient Egypt. Exhibit at the Brooklyn Museum, New York, December 15, 2016–December 1, 2017.

MACHINERY & MODERN WOMEN

Burns, Ken, director. *Prohibition.* Documentary series. PBS, 2011.

Caravantes, Peggy. *The Many Faces of Josephine Baker: Dancer, Singer, Activist, Spy.* Chicago: Chicago Review Press, 2017.

Davis, Lon. *Silent Lives: 100 Biographies of the Silent Film Era.* Albany, GA: BearManor Media, 2012.

Dilg, Janice. "Harriet 'Hattie' Redmond (1862–1952)." *The Oregon Encyclopedia.* https://oregonencyclopedia.org/articles/redmond_harriet_hattie/#.WZRT1FGGM2w.

Geczy, Adam. *Fashion and Orientalism: Dress, Textiles and Culture from the 17th to the 21st Century.* New York: Bloomsbury Academic, 2013.

Hines, Ron. "Do Exotic Cats Make Good Pets?" 2nd Chance. http://2ndchance.info/big_cats.htm.

"Josephine Baker." Biography.com, A&E Television Networks. http://www.biography.com/people/josephine-baker-9195959.

Mackrell, Judith. *Flappers: Six Women of a Dangerous Generation.* New York: Macmillan, 2013.

McQuiston, Liz. *Suffragettes to She-Devils: Women's Liberation and Beyond.* New York: Phaidon Press, 1997.

"State Laws for Keeping Exotic Cats." Big Cat Rescue. https://bigcatrescue.org/state-laws-exotic-cats/.

Tortora, Phyllis G. *Dress, Fashion and Technology from Prehistory to the Present.* New York: Bloomsbury Academic, 2015.

von Drehle, David. *Triangle: The Fire that Changed America.* Charlotte, NC: Paw Prints/Baker & Taylor, 2008.

FEMMES FATALES & FASHION SHOWS

"Adrian: Hollywood and Beyond." Website and exhibit at the Museum at FIT, New York, March 7–April 1, 2017. http://exhibitions.fitnyc.edu/adrian-hollywood-and-beyond/.

Aliperti, Cliff. "Wampas Baby Stars of 1922–1934 with Photos of Each Class." Immortal Ephemera. http://immortalephemera.com/wampas-baby-stars/.

Idacavage, Sara. "Fashion History Lesson: The Evolution of Runway Shows." Fashionista, September 19, 2016. http://www.fashionista.com/2016/09/fashion-week-history.

Keesey, Pam. Vamps: An Illustrated History of the Femme Fatale. Jersey City, NJ: Cleis Press, 1997.

Laverty, Christopher. Fashion in Film. London: Laurence King Publishing, 2016.

Parkins, Ilya. Poiret, Dior and Schiaparelli: Fashion, Femininity and Modernity. New York: Berg, 2012.

Shaw, Lisa. "Carmen Miranda's Fashion: Turbans, Platform Shoes and a Lot of Controversy." The Guardian, August 5, 2015. http://www.theguardian.com/fashion/2015/aug/05/carmen-mirandas-fashion-turbans-platform-shoes-and-a-lot-of-controversy.

Sklar, Robert. Movie-Made America: A Cultural History of American Movies. New York: Vintage Books, 2010.

Wikipedia contributors. "Marian Nixon." Wikipedia, the Free Encyclopedia. https://en.wikipedia.org/wiki/Marian_Nixon.

HAUTE CAT-OURE

Dior, Christian. The Little Dictionary of Fashion. New York: Abrams, 2007.

———. Dior by Dior: The Autobiography of Christian Dior. Translated by Antonia Fraser. London: V&A Publishing, 2015.

Guenther, Irene. Nazi Chic?: Fashioning Women in the Third Reich. New York: Berg, 2010.

Pochna, Marie-France. Christian Dior: The Man Who Made the World Look New. Translated by Joanna Savill. New York: Arcade Publishing, 1996.

Schulman, Faye. A Partisan's Memoir: Woman of the Holocaust. Toronto, Canada: Second Story Press, 1995.

BOUDOIRS, BOMBSHELLS & BIKINIS

Alac, Patrik. Bikini Story. New York: Parkstone International, 2015.

Blum, Sarajane, and Louis Meisel. The Art of Pin-Up. Edited by Dian Hanson. Cologne, Germany: Taschen, 2014.

Bramlett, Lizzie. "Vanity Fair." Vintage Fashion Guild. https://vintagefashionguild.org/label-resource/vanity-fair/.

"Cordie King Is the Lady in the Lake." Hue, November 1955. Flickr image. Posted by user Vieilles Annonces, July 9, 2009. https://www.flickr.com/photos/vieilles_annonces/1393824975.

Geerhart, Bill. "Atomic Goddess Revisted: Rita Hayworth's Bomb Image Found!" Conelrad Adjacent. http://conelrad.blogspot.com/2013/08/atomic-goddess-revisited-rita-hayworths.html.

Gottwald, Laura, and Janusz Gottwald, editors. Frederick's of Hollywood, 1947–1973: 26 Years of Mail Order Seduction. New York: Castle Books, 1973.

Harrington, Cora. The Lingerie Addict. http://www.thelingerieaddict.com.

Kelly, Erin. "An Illustrated History of the Pin-Up Girl." All That Is Interesting. http://www.all-that-is-interesting.com/pin-up-history.

Wikipedia contributors. "History of the Bikini." Wikipedia, the Free Encyclopedia. https://en.wikipedia.org/wiki/History_of_the_bikini.

THE TROPHY WIFE

Cassini, Oleg. *A Thousand Days of Magic: Dressing Jacqueline Kennedy for the White House*. New York: Rizzoli, 2014.

Donnally, Trish. "Animal Rights Activists Continue to Pelt Fur Trade." *San Francisco Chronicle*, August 9, 1999. http://sfgate.com/news/article/Animal-Rights-activists-continue-to-pelt-fur-trade-2915821.php.

"Hackles Up Over Fur Coat." *Los Angeles Times*, February 4, 1968, p. 294. Reprinted on Newspapers.com. https://www.newspapers.com/newspage/164657882/.

John F. Kennedy Presidential Library and Museum. https://www.jfklibrary.org.

Lawrence, Greg. *Jackie as Editor: The Literary Life of Jacqueline Kennedy Onassis*. New York: Thomas Dunne Books, 2011.

"Of Ladies and Leopard Coats." *Mansfield Ohio News-Journal*, January 25, 1968. Reprinted on Newspapers.com. https://www.newspapers.com/newspage/46180951/.

Somtv. "Premier Minister Abirashid Ali Shermarke Meets with Pres. John F. Kennedy." YouTube video, 10:07. Posted April 28, 2010. http://www.youtube.com/watch?v=zOGLLjIBkWw.

Wilcox, R. Turner. *The Mode in Furs: A Historical Survey with 680 Illustrations*. Mineola, NY: Dover, 2010.

THE BAD MOTHER

Collins, Gail. *When Everything Changed: The Amazing Journey of American Women from 1960 to the Present*. Boston: Little, Brown and Co., 2014.

Fetters, Ashley. "4 Big Problems with *The Feminine Mystique*." *The Atlantic*, February 12, 2013. http://www.theatlantic.com/sexes/archive/2013/02/4-big-problems-with-the-feminine-mystique/273069.

Friedan, Betty. *The Feminine Mystique*. 1963. New York: W.W. Norton & Company, 2013.

Kashner, Sam. "Here's to You, Mr. Nichols: The Making of *The Graduate*." *Vanity Fair*, February 25, 2008. https://www.vanityfair.com/news/2008/03/graduate200803.

FUN FUR

Bolton, Andrew. *Punk: Chaos to Couture*. New York: Metropolitan Museum of Art, 2013.

"Fashion, Then and Now." Conference at LIM College, October 2016.

Hallay, Amanda. "Spotlight: Biba and the Deco Revival (An Ultimate Fashion History Special)." The Ultimate Fashion History. YouTube video, 17:04. Posted November 26, 2015. http://www.youtube.com/watch?v=qoPsn14eCK0.

——. "Spotlight: Original Punk Rock Fashion (An Ultimate Fashion History Special)." The Ultimate Fashion History. YouTube video, 12:44. Posted November 26, 2015. http://www.youtube.com/watch?v=9KyppYZQzXw.

Hilfiger, Tommy. *Rock Style: A Book of Rock, Hip-Hop, Pop, R&B, Punk, Funk and the Fashions that Give Looks to Those Sounds*. New York: Universe, 2000.

Kearney, Mary Celeste. *Gender and Rock*. New York: Oxford University Press, 2017.

Reed, Paula. *Fifty Fashion Looks that Changed the 1970s*. London: Conran Octopus, 2012.

Shellist, Lorelei. *Runway Runaway: A Backstage Pass to Fashion, Romance and Rock 'n Roll*. Los Angeles: Siren Star Publishing, 2010.

Stern, Jane, and Michael Stern. *The Encyclopedia of Bad Taste*. New York: Harper Perennial, 1991.

Thomas, Steven, and Alwyn W. Turner. *Welcome to Big Biba: Inside the Most Beautiful Store in the World*. Woodbridge, United Kingdom: Antique Collectors' Club Distribution, 2011.

Waters, John. *Shock Value: A Tasteful Book About Bad Taste*. New York: Dell, 1981.

I WANT MY LEOPARD PRINT

"1980 to 1990." Vintage Fashion Guild. http://vintagefashionguild.org/fashion-timeline/1980-to-1990.

Black Fashion Designers. Exhibit at the Museum at FIT, New York, December 6, 2016–May 16, 2017.

DeLeon, Jian. "The Greatest 80s Fashion Trends: Animal Print." Complex, July 19, 2017. http://www.complex.com/style/the-greatest-80s-fashion-trends/animal-print.

Gross, Michael. "Rock Videos Shape Fashion for the Young." New York Times, December 27, 1985. http://www.nytimes.com/1985/12/27/style/rock-videos-shape-fashion-for-the-young.html.

Gruen, Victor. Shopping Town: Designing the City in Suburban America. Edited and translated by Anette Baldauf. Minneapolis: University of Minnesota Press, 2017.

Howard, Vicki. From Main Street to Mall: The Rise and Fall of the American Department Store. Philadelphia: University of Pennsylvania Press, 2015.

Marasigan, Cherish. "The Evolution of Glam Rock Fashion." RebelsMarket, January 11, 2017. http://www.rebelsmarket.com/blog/posts/the-evolution-of-glam-rock-fashion.

Patrick Kelly: A Retrospective. Exhibit at the Brooklyn Museum, New York, April 17–September 5, 2004. http://www.brooklynmuseum.org/exhibitions/patrick_kelly.

Piazza, Arianna. Hip Hop Stylography: Street Style and Culture. Milan, Italy: Ore Cultural Srl., 2017.

Tannenbaum, Rob, and Craig Marks. I Want My MTV: The Uncensored Story of the Music Video Revolution. New York: Plume, 2012.

SUPERMODELS & STRIPTEASERS

Baldwin, Michelle. Burlesque and the New Bump-n-Grind. Denver: Speck Press, 2004.

Guffey, Elizabeth E. Retro: The Culture of Revival. London: Reaktion, 2006.

Milligan, Lauren. "When Supermodels Ruled the World." British Vogue, January 16, 2016. http://www.vogue.co.uk/gallery/nineties-supermodels-pictures-christy-cindy-linda-naomi-claudia.

"A Natural History of Leopard Print." The Quantum Biologist, June 26, 2011. https://quantumbiologist.wordpress.com/2011/06/26/a-natural-history-of-leopard-print/

Phillips, Ian. "How We Met: Naomi Campbell and Azzedine Alaia." The Independent, April 4, 1998. http://www.independent.co.uk/arts-entertainment/how-we-met-naomi-campbell-and-azzedine-alaia-1154742.html.

von Teese, Dita, and Bronwyn Garrity. Burlesque and the Art of the Teese/Fetish and the Art of the Teese. New York: HarperCollins, 2006.

Zemeckis, Leslie. Behind the Burly Q: The Story of Burlesque in America. New York: Skyhorse Books, 2013.

SPOTTED EVERYWHERE

"Animal Print Psychology." Marketing Futures, September 15, 2012. http://www.marketingfutures.com/2012/09/15/cougafication-the-psychology-behind-animal-print/

BronxNet. "From Mobutu to Beyoncé at the Bronx Documentary Center." YouTube video, 2:18. Posted April 25, 2017. https://www.youtube.com/watch?v=XeJmBfV7mW0.

DB Movie Creations. "Latest Animal Print Saree Design Collections." YouTube video, 3:00. Posted February 25, 2017. http://www.youtube.com/watch?v=aNxNZsCZAjc.

"Dolce & Gabbana: A Story of Millenials & More at Milan Fashion Week." ShopUnder blog. http://www.shopunder.com/blog/dolce-gabbana-story-millenials-milan-fashion-week/.

Dumbula, Joseph. "Malawian Chief, Kachindamoto Nominated for the 2017 New African Woman Awards." Malawi 24, April 7, 2017. http://www.malawi24.com/2017/04/07/malawian-chief-kachindamoto-nominated-for-the-2017-new-african-woman-awards/.

Ellese. "Is Leopard Print the New Girl Boss Symbol?" Rock.Paper.Glam., January 27, 2017. http://www.rockpaperglam.com/leopard-print-everything/.

Fariha. "Leopard Print Hijab Ideas for Modish Girls." Girls Hijab Style & Hijab Fashion Ideas. http://www.girlshijab.com/hijjab/leopard-print-hijab-ideas-for-modish-girls.php.

Iddon, Martin, and Melanie L. Marshall, eds. Lady Gaga and Popular Music: Performing Gender, Fashion, and Culture. New York: Routledge, 2014.

Kahn, Eve M. "Dressed to Kill: The Power of Leopard Prints." New York Times, April 28, 2016. http://www.nytimes.com/2016/04/29/arts/design/dressed-to-kill-the-power-ofleopard-prints.html?mcubz=0.

Le Blanc, Steven, and Masami M. "Which Japanese Prefecture Buys the Most Leopard Print Clothes?" SoraNews24, March 31, 2017. http://en.rocketnews24.com/2017/03/31/which-japanese-prefecture-buys-the-most-leopard-print-clothes/

Yuan, Jada, Maurizio Cattelan, and Pierpaolo Ferrari. "Now, This Is a Supermodel." The Cut, August 6, 2017. http://www.thecut.com/2017/08/ashley-graham-supermodel.html.

#LEOPARDPRINT

Black, Sandy. The Sustainable Fashion Handbook. New York: Thames & Hudson, 2013.

Claudio, Luz. "Waste Couture: Environmental Impact of the Clothing Industry." Environmental Health Perspectives 115, no. 9 (2007): A449–1454. https://www.ncbi.nlm.nih.gov/pmc/articles/PMC1964887/

Joubert, Dereck, and Beverly Joubert. Eye of the Leopard. New York: Rizzoli, 2009.

Medine, Leandra. "Leopard Print Nails? So On It." Man Repeller, February 4, 2011. http://www.manrepeller.com/2011/02/leopard-print-nails-so-on-it.html.

"News and Highlights." Convention on International Trade in Endangered Species of Wild Fauna and Flora. http://www.cites.org/eng.

Powers, Lindsay. "Nicki Minaj Explains Wild Leopard Grammy Outfit." Hollywood Reporter, February 13, 2011. http://www.hollywoodreporter.com/news/nicki-minaj-explains-wild-leopard-99148.

Ryder, Katie. "The Meaning of Leopard Print." The New Yorker, June 21, 2017.

Spinski, Tristan. "A Mausoleum for Endangered Species." New York Times, July 10, 2017. http://www.nytimes.com/2017/07/10/science/national-wildlife-property-repository-colorado.html?mcubz=0.

Square, Jonathan Michael, and Kimberly M. Jenkins. "Fashion and Justice." Workshop at the Parsons School of Design, New York, July 15, 2017.

U.S. Fish and Wildlife Service National Wildlife Property Repository. http://www.fws.gov/wildliferepository/index.php.

Yotka, Steff. "There's Strength in Spots: Leopard Print Is Fall's Most Powerful Trend." Vogue, March 22, 2016. http://www.vogue.com/article/leopard-print-runway-trend-fall-2016.

Acknowledgments

This project required plenty of insight and direction from friends and strangers alike. I had no idea what I was getting into and have appreciated every suggestion, correction, and discovery.

For support of every kind, I salute the world's second-foremost authority on the history of leopard print, my darling squee, Jonathan Van Gieson. From listening and helping me with revisions to doing image research and formatting image-related documents, he made this book possible.

I must give thanks to the goddesses of publishing who helped make this a real-live book: Thanks to Brandi Bowles, my awesome agent, for taking another chance on me. Thanks to Rebecca Hunt for giving this project its big break. Thanks to Signe Bergstrom, for working as if it was her own project. Thanks to Cristina Garces for keeping it alive. Thanks to Laura Palese, our endlessly patient designer, for her magic-making.

Much appreciation to: Polly Wood, for assistance, organization, and a great eye; Ana Mari Quesada at The Wild Project, for supporting my fledgling efforts; Cory Petit, for pro scans and parallel parking; Nicole La Moreaux at LIM College, for the opportunity to present my work to fashion experts and historians; Joanna Ebenstein at Morbid Anatomy, for encouraging the project and hosting the pop-up Museum of Leopard Print; Bettie Blackheart at Helsinki Burlesque Festival, for a chance to take it international; Indigo Blue, for being there when I came up with the idea, and for being there always; Michelle Baldwin, for belief and outstanding style; Lady Aye, for goats and other forms of sustenance; Christine and Alex Colby, for being delicious, delicious; Cora Harrington, for her insights into ethical clothing manufacture; Rosey LaRouge, for, among other things, letting me know that, yes, getting images is just that hard; Malgorzata Saniewska, Ben Trivett, Bettina May, and David Byrd, for early leopard photo shoots; the New York Public Library, for infinite resources and the most beautiful writing space in the world; Elizabeth Gay at FIT, for letting me get up close to fabled garments; Kimberly Jenkins at Fashion and Justice, for discussion on the colonization of fashion history; Barbie Beach, for

adorable photos from the first "History of Leopard Print" lecture; Scott Ewalt, for finding the best stuff on eBay; Lowa DeBoomBoom, for alerting me to problematic uses of the pattern; Veronica Varlow, for endless magic; Gala Darling, for encouragement; Matt Knife, for onsite-draping; Sizzle Dizzle, for tea and cupcakes; Beelzebabe, for support and general leopard-wearing; Perle Noire, for friendship and focus during a hard time; Julie Atlas Muz, for the push; Judith Boyd, for shared delight in the print; Neil "Nez" Kendall for legends in leopard; Debra Rappaport, for enthusiasm; Jefferson and Selene Arca and all the great staff at Clocktower Cabaret, for helping me put on a show my mom could attend; Miriam Tucker at Rago Arts, for giving me a new audience; Leslie Zemeckis, for flying the leopard flag; Eve M. Kahn at the *New York Times,* for thought-provoking questions; my NOLA friends, for giving me sanctuary in New Orleans; Lux LaCroix, for alerting me to blaxploitation imagery; Whitney Ward and Joe Coleman, for being true found family; Ellie, for making leopard hats for the women's march; The Posse of Lily, Deb, and Jill; Julie Atlas Muz; and Stripsters—you know who you are.

And thanks to everybody who sent me or tagged me in pictures of leopard print. Don't stop, I'm not sick of it.

Special thanks to every leopard-print loving goddess, legend, and hero mentioned in this book, and a few who didn't make it past the final edits. What I presented here is merely the tip of the iceberg, and if it prompts you to dive deeper on your own, the many hours of research that *didn't* make it into this book will have been worth it. Thank you for reading!

Photo Credits

Illustration from *National Police Gazette*, November 2, 1895: 1; mimagephotos / Adobe Stock: 2; © 20th Century Fox Film Corp. All rights reserved, courtesy: Everett Collection: 8; Michael Ochs Archives / Getty Images: 12; Eliot Elisofon / The LIFE Picture Collection / Getty Images: 18–19; Subbotina Anna / Adobe Stock: 20; from top to bottom, © Friday / © edelwsirilipix / © EcoView / © nico99 / © wildarun / © ovb64 / © SunnyS / © Eric Isselée / Adobe Stock: 25; illustration from *Johnson's Household Book of Nature* /Author Collection: 26 and 219; illustration by Joseph Wolf from *Proceedings of the Zoological Society of London* / Wikimedia Commons: 28; © Papa Bravo / Adobe Stock: 29; illustration from *The Viviparous Quadrupeds of North America* by J.W. Audubon / The New York Public Library Digital Collections: 30, 34, 36; © Alfred / Adobe Stock: 31; illustration by R. Friense from *Brockhaus' Konversations-Lexicon* / Author Collection: 32 and 40; © stuporter / Adobe Stock: 33; © photogallet / Adobe Stock: 35; © Andrea Izzotti / Adobe Stock: 37; illustrations by G. Mützel from *Meyer's Lexicon* / Author Collection: 38 and 42; © Abeselom Zerit / Adobe Stock: 39; © Sarah Cheriton-Jones / Adobe Stock: 41; © Eric Isselée / Adobe Stock: 43; (CC) Nevit Dilmen / Wikimedia Commons: 47; Metropolitan Museum of Art: 48, 52 bottom, 54, 57, 59; painting by Charles Edward Perugini / via Wikimedia Commons: 48 right; illustration from *Shan Hai Jing (The Classic of Mountains and Seas)* / Library of Congress: 50 left; illustration of Freya / via Wikimedia Commons: 50 right; Superstock / Everett Collection: 51; via Wikimedia Commons: 52 top; © Constantinos / Adobe Stock: 64; Chicopee Sewing Machine Co. / Library of Congress: 65; Bain News Service / Library of Congress: 66, 71; Courtesy Oregon Historical Society Research Library, 68; Karen Augusta / Augusta Auctions: 69; *Ladies Home Journal*: 72; Ruth Harriet Louise / Moviepix Collection / Getty Images: 75; Michael Ochs Archives / Getty Images: 77 left; Bettman / Getty Images: 77 right; Hartsook / Library of Congress: 81; Fernand Khnopff / at Royal Museums of Fine Arts of Belgium / via Wikimedia: 82–83; courtesy Everett Collection: 84, 89, 90, 92, 93, 102, 105, 106, 111, 114, 117, 131, 134, 141, 145 bottom left, and bottom right, 146, 151, 163, 170 left; © Talbot / Galliera / Roger-Viollet / The Image Works: 85 left; © 20th Century Fox Film Corp. All rights reserved, Courtesy: Everett Collection: 85 right; photo by Jean Reutlinger / via Wikimedia Commons: 86; iconicdresses.co.uk: 88; Francois Duhamel © Universal Studios / courtesy Photofest NYC: 91; Gilbert Adrian / Image @ The Metropolitan Museum of Art / Image Source: Art Resource NYC: 95; Pat English / The LIFE Images Collection / Getty Images: 99; Kurt Hutton / Picture Post / Getty Images: 101; Cecil Beaton / © The Cecil Beaton Studio Archive at Sotheby's: 103; via Wikimedia Commons: 112 top; illustration by Charles Dana Gibson / 112 bottom; Leo Vals / Hulton Archive / Getty Images: 115; @ Olivia De Berardinis all rights reserved / Bettie Page™ is a trademark of Bettie Page

About the Author

JO WELDON is an expert in the study of contemporary burlesque, women's issues, and retro fashion. Her lectures and events about the history of leopard print have been featured in *Mental Floss, The Financial Times,* and the *New York Times,* as well as international style magazines in Dubai, Ukraine, and Helsinki. As headmistress of the New York School of Burlesque, she teaches and performs internationally. Weldon combines years of professional experience as an adult entertainer with a deep understanding of women's rights. She has presented media analyses of proposed legislation related to gender and labor in conferences around the country, and has lobbied at the U.N. for inclusion of diverse perspectives in human rights initiatives. She lives in New York City. You can find more of her work, and more about leopard print, at www.joweldon.com.